I Am Also A You

Clarkson N. Potter, Inc./Publisher NEW YORK

DISTRIBUTED BY CROWN PUBLISHERS, INC.

I Am Also A You

A Book of Thoughts with Photographs

by

JAY THOMPSON

with an introduction by

John Lennon

design by Michael Lunstead

Eighth Printing, February, 1975

Grateful acknowledgment is made for permission to reprint quotes from the following:

"The Anatomy of Loneliness," Thomas Wolfe, American Mercury Magazine, October 1941, from The Great Quotations, compiled by George Seldes. Copyright ©1960 and 1966 by George Seldes, Lyle Stuart, Inc.

"Columbia University Bicentennial Dinner Address," Dwight David Eisenhower, May 31, 1954, from The Great Quotations, compiled by George Seldes. Copyright 1960 and 1966 by George Seldes, Lyle Stuart, Inc.

Original poem, Jim Gorman, 1969, Puma Gallery, San Francisco.

South Wind, Norman Douglas, from The Great Quotations, compiled by George Seldes. Copyright ©1960 and 1966 by George Seldes, Lyle Stuart, Inc.

Annalen der Physic, Albert Einstein, 1905, from The Great Quotations, compiled by George Seldes. Copyright © 1960 and 1966 by George Seldes, Lyle Stuart, Inc.

India News, Jawaharlal Nehru, 1958, quoted by Gazette & Daily, York, Pennsylvania, February 10, 1958, from The Great Quotations, compiled by George Seldes. Copyright ©1960 and 1966 by George Seldes, Lyle Stuart, Inc.

A lecture given by Arthur C. Clarke and reprinted by permission of the author, Arthur C. Clarke, and the author's agent, Scott Meredith Literary Agency, Inc.

The Varieties of Religious Experience, William James, 1902, Alexander R. James, literary executor, Paul R. Reynolds, Inc.

Zen Buddhism, Christmas Humphreys, Copyright ©1956, Crowell Collier & Macmillan, Inc.

Leaves of Gold, Robert Louis Stevenson, 1948, Coslett Publishing Co.

Living the Infinite Way, Joel Goldsmith, 1947, revised edition 1961, Harper & Row Publishers, Inc.

The Prophet, Kahlil Gibran, with permission of the publisher, Alfred A. Knopf, Inc. Copyright 1923 by Kahlil Gibran and renewed 1951 by Administrators C.T.A. of Kahlil Gibran estate and Mary G. Gibran.

The Sky Clears, A. Grove Day, 1964, Bison Book Edition, by permission of University of Nebraska Press.

Texts and Pretexts, Aldous Huxley, 1933, Harper & Row, Publishers, Inc.

The Master Game, Robert S. deRopp, Dell Publishing Co., Inc. ©1968, A Seymour Laurence Book/Delacorte Press.

"A Letter From Lindbergh," Life Magazine, July 4, 1969, ©1969 Time Inc.

2001: A Space Odyssey, Arthur C. Clarke. Reprinted by permission of The World Publishing Co. An NAL book. Copyright © 1968 by Polaris Productions, Inc., and Arthur C. Clarke.

Steppenwolf, Herman Hesse. Translated by Basil Creighton. Holt, Rinehart and Winston, Inc., 1929, ©1957.

Quote by Albert Einstein from The New York Times obituary, April 19, 1955, © 1955 by The New York Times Company. Reprinted by permission.

The Joyous Cosmology, Alan W. Watts, copyright © 1962, Pantheon Books, a division of Random House, Inc.

Thus Spake Zarathustra, Friedrich Nietzche, from The Great Quotations, compiled by George Seldes. Copyright ©1960 and 1966 by George Seldes, Lyle Stuart, Inc.

U.S. Supreme Court Opinion, William J. Brennan, Jr., Roth vs U.S., 354 U.S.A. 476, 1957, from The Great Quotations, compiled by George Seldes. Copyright ©1960 and 1966 by George Seldes, Lyle Stuart, Inc.

Supreme Court Decision, William O. Douglas, from The Great Quotations, compiled by George Seldes. Copyright © 1960 and 1966 by George Seldes, Lyle Stuart, Inc.

The Simple Way, Lao-Tse, from The Great Quotations, compiled by George Seldes. Copyright © 1960 and 1966 by George Seldes, Lyle Stuart, Inc.

Guatama Buddha, from The Great Quotations, compiled by George Seldes. Copyright ©1960 and 1966 by George Seldes, Lyle Stuart Inc.

Song, "One," Nilsson, from Aerial Ballet, RCA Victor, ©1968. Reprinted by permission of Dunbar Music, Inc. (BMI).

Song, "I Got Life," from the book and musical Hair Book and lyrics by Gerome Ragni and James Rado, music by Galt McDermot. ©1967 by Channel H Productions. Reprinted by permission of United Artists Music, Inc.

Song, "I Am the Walrus," Lennon/McCartney, from Magical Mystery Tour, © 1967. Reprinted by permission of Maclen Music, Inc., a division of Kirshner Entertainment Corporation.

Song, "Tomorrow Never Knows," Lennon/McCartney, Revolver, ® 1966. Reprinted by permission of Maclen Music, Inc., a division of Kirshner Entertainment Corporation.

Song, "Baby, You're a Rich Man," Lennon/McCartney, Magical Mystery Tour, ©1967. Reprinted by permission of Maclen Music, Inc., a division of Kirshner Entertainment Corporation.

To my teachers:

BARBARA MARY MUHL ALAN WATTS THE BEATLES

SPECIAL THANKS TO:

Michael Bernsohn

David Shepard

Harry Nilsson

Jose de Vega

Dick de Neut

Rick Nathanson

Introduction

by

John Lennon

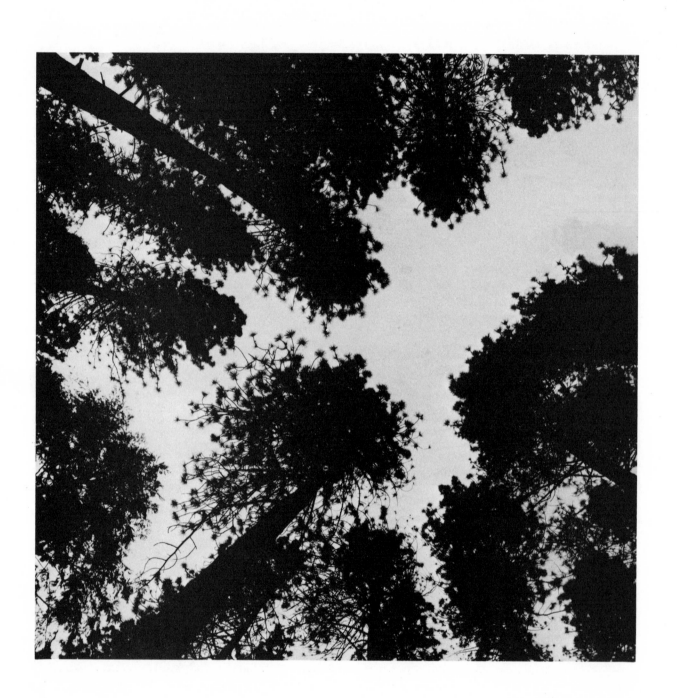

rest in peace

If it is the truth, what does it matter who said it?

Anonymous

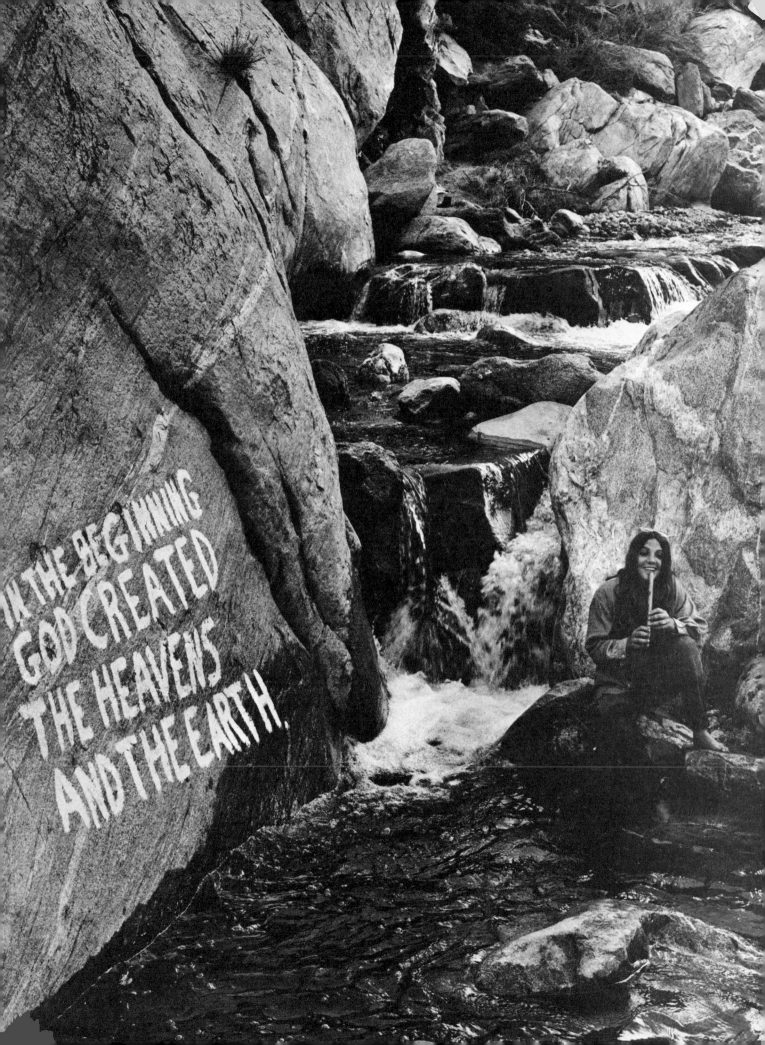

IN THE BEGINNING GOD CREATED THE HEAVENS AND THE EARTH.

Things do not change; we change.

Henry David Thoreau

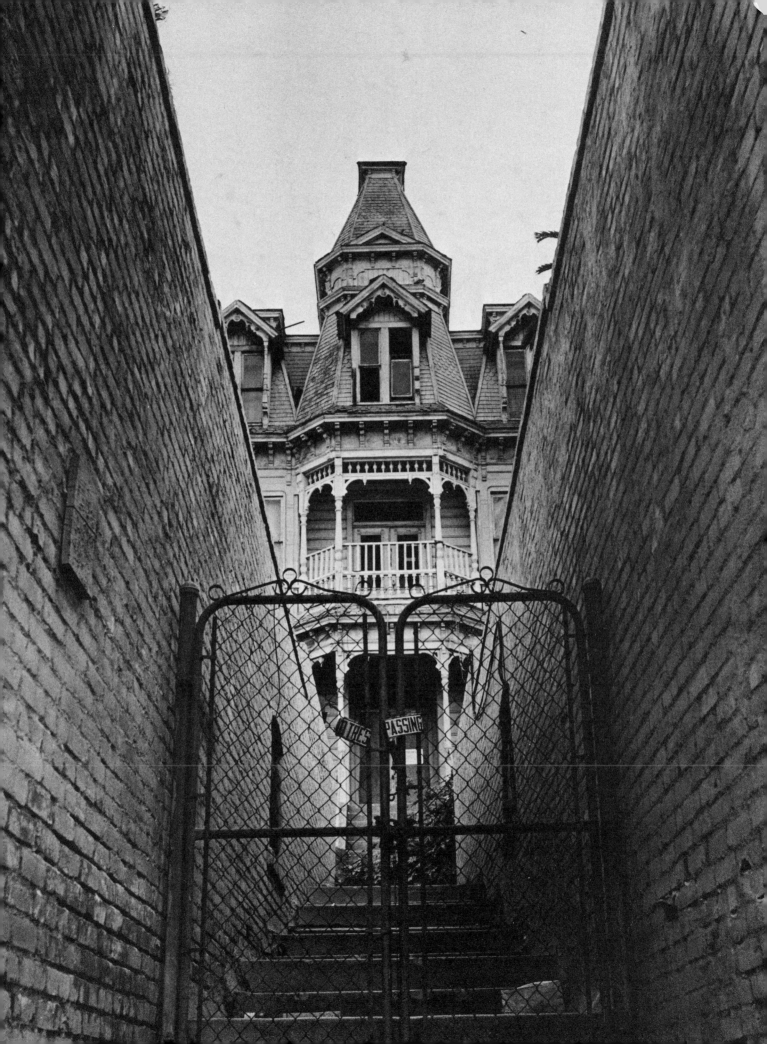

There is a change in society. There must be a corresponding change in the government. We are not, we cannot, in the nature of things, be, what our fathers were.

Thomas Babington Macaulay, 1831

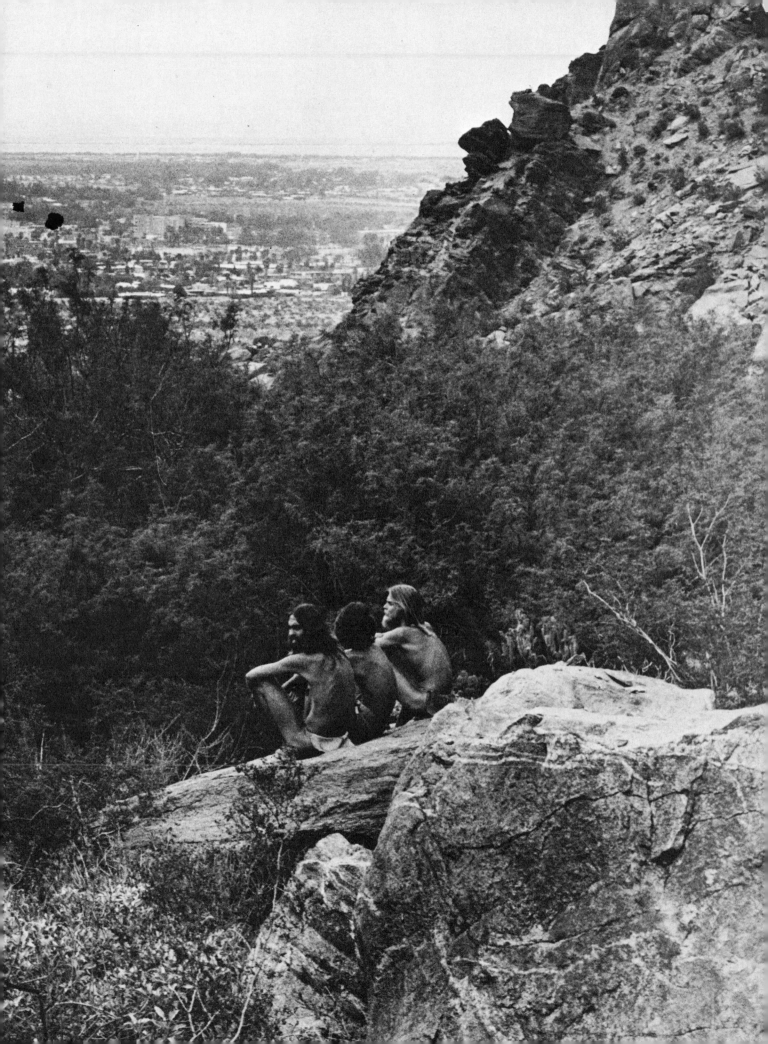

By the accident of fortune a man
may rule the world for a time, but by virtue of love
he may rule the world forever.

Lao-Tse

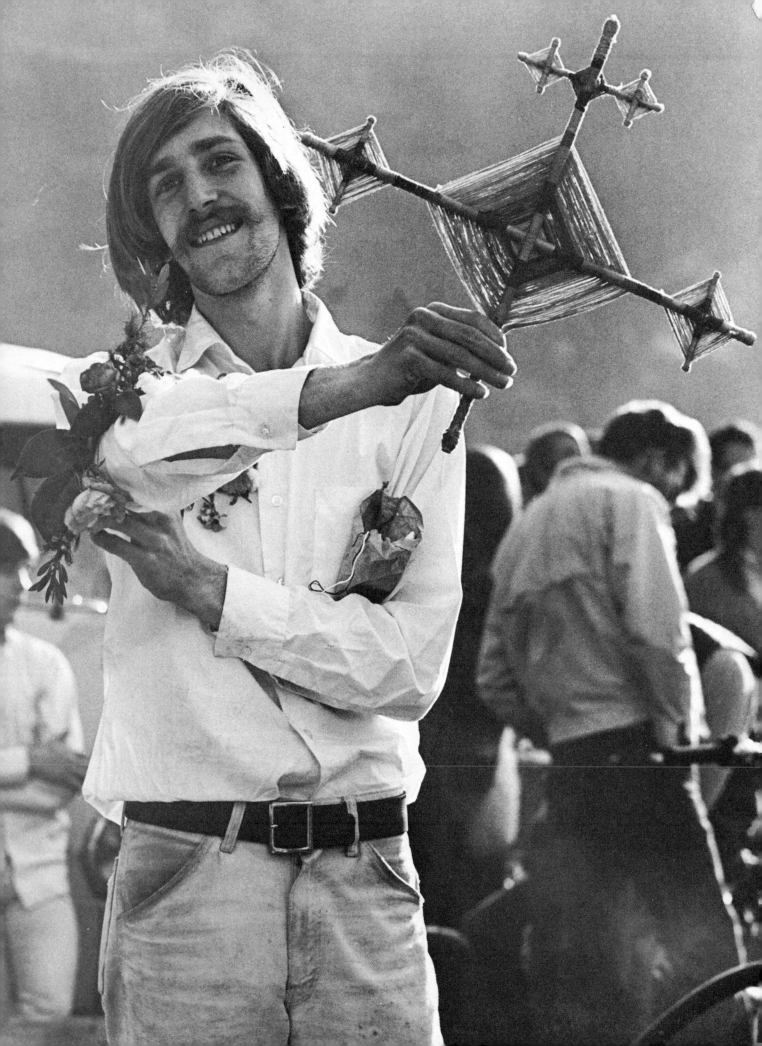

My religion consists of a humble admiration of the illimitable superior spirit who reveals himself in the slight details we are able to perceive with our frail and feeble minds. That deeply emotional conviction of the presence of a superior reasoning power, which is revealed in the incomprehensible universe, forms my idea of God.

Albert Einstein

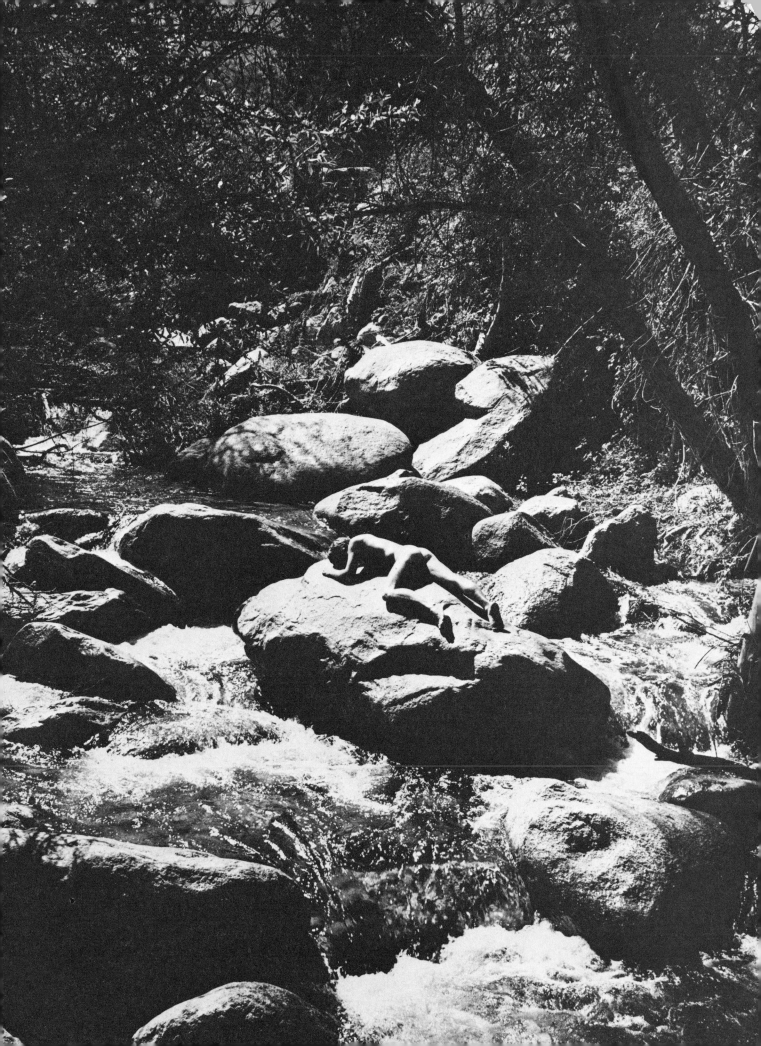

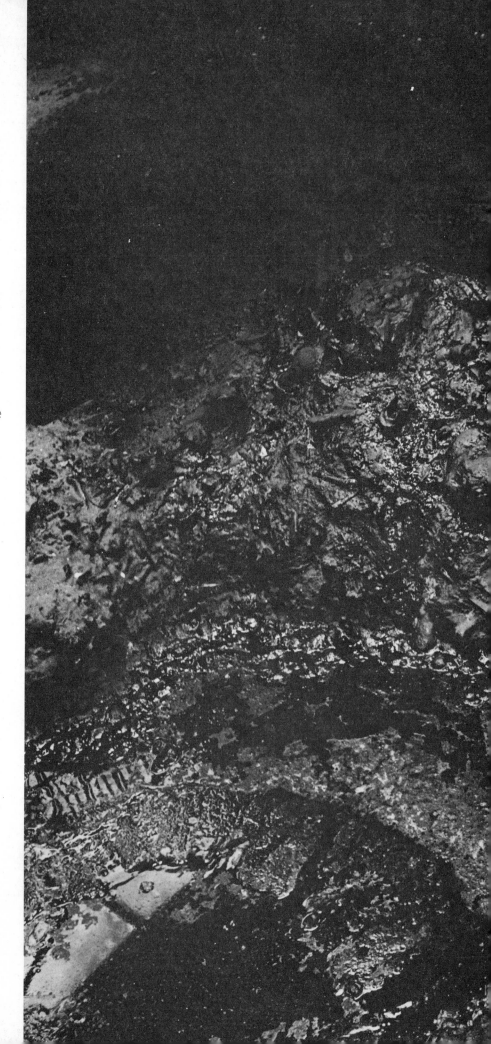

...we look up in
the skies today with a
new awareness —
knowing that ours may
well be the last
generation that
thought itself alone.

Arthur C. Clarke

La Brea Tar Pits

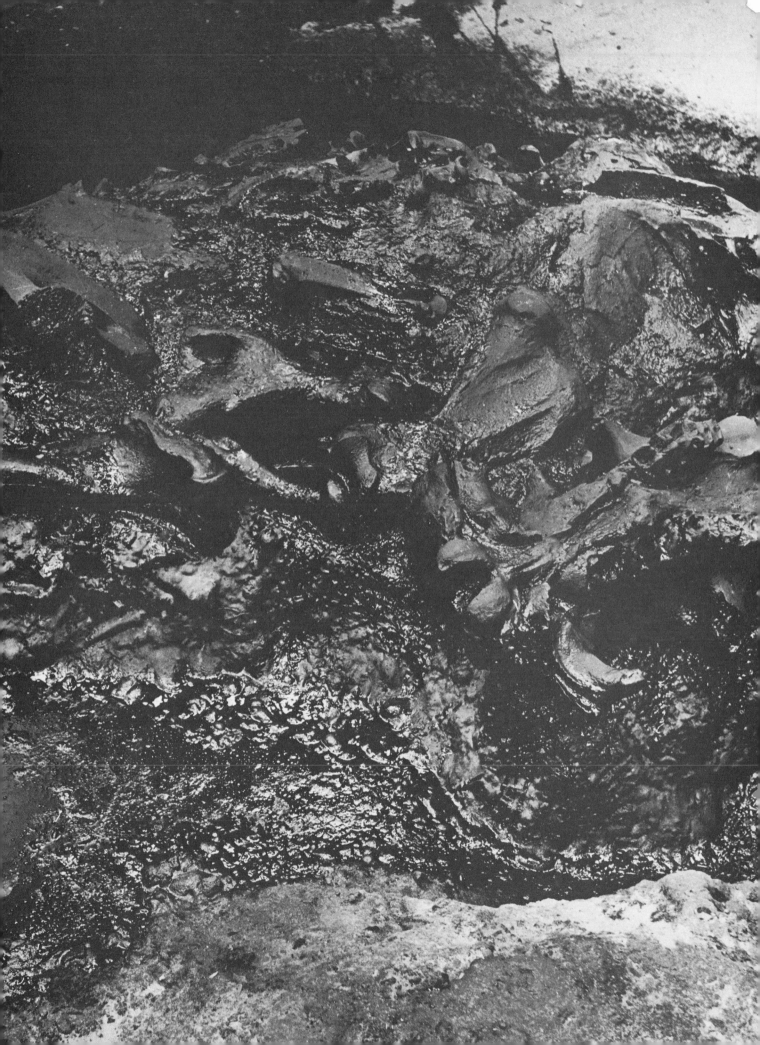

Here in America we are descended in blood and spirit from revolutionists and rebels — men and women who dare to dissent from accepted doctrine. As their heirs, we may never confuse honest dissent with disloyal subversion.

Dwight D. Eisenhower, 1954

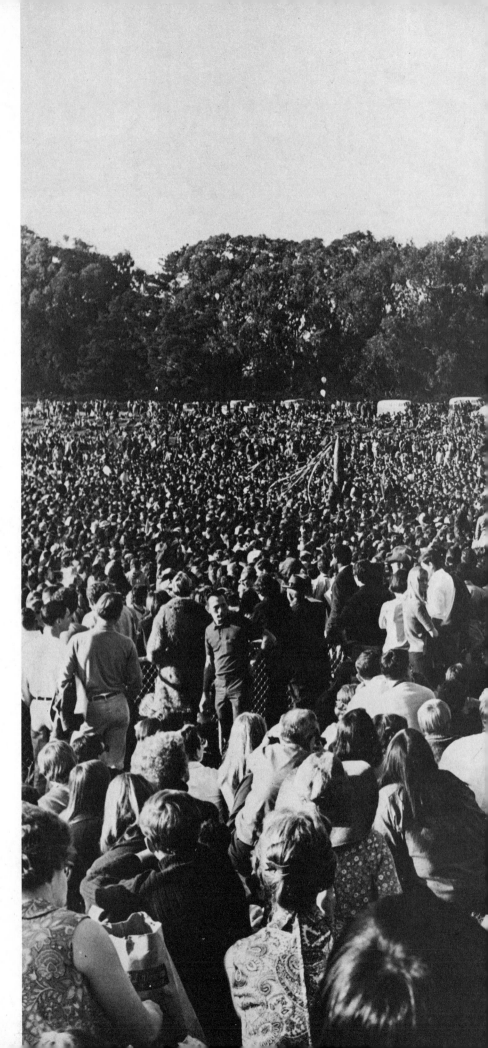

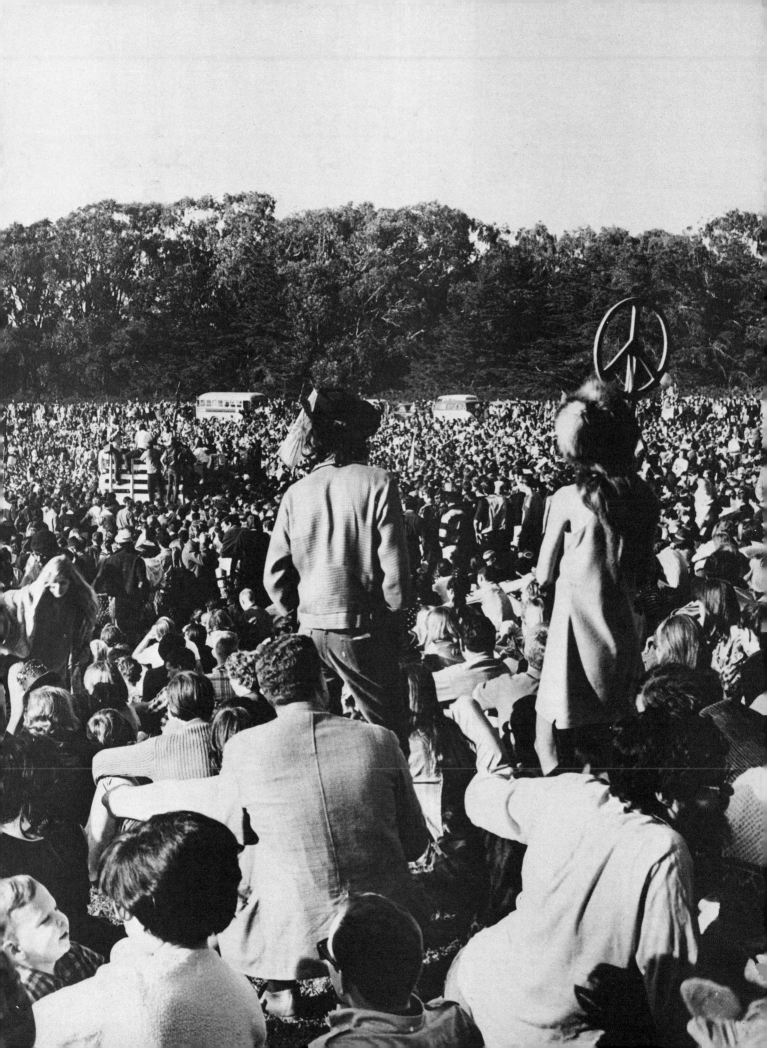

No one is more dangerously insane than one who is sane all the time: he is like a steel bridge without flexibility, and the order of his life is rigid and brittle.

Alan Watts, 1962

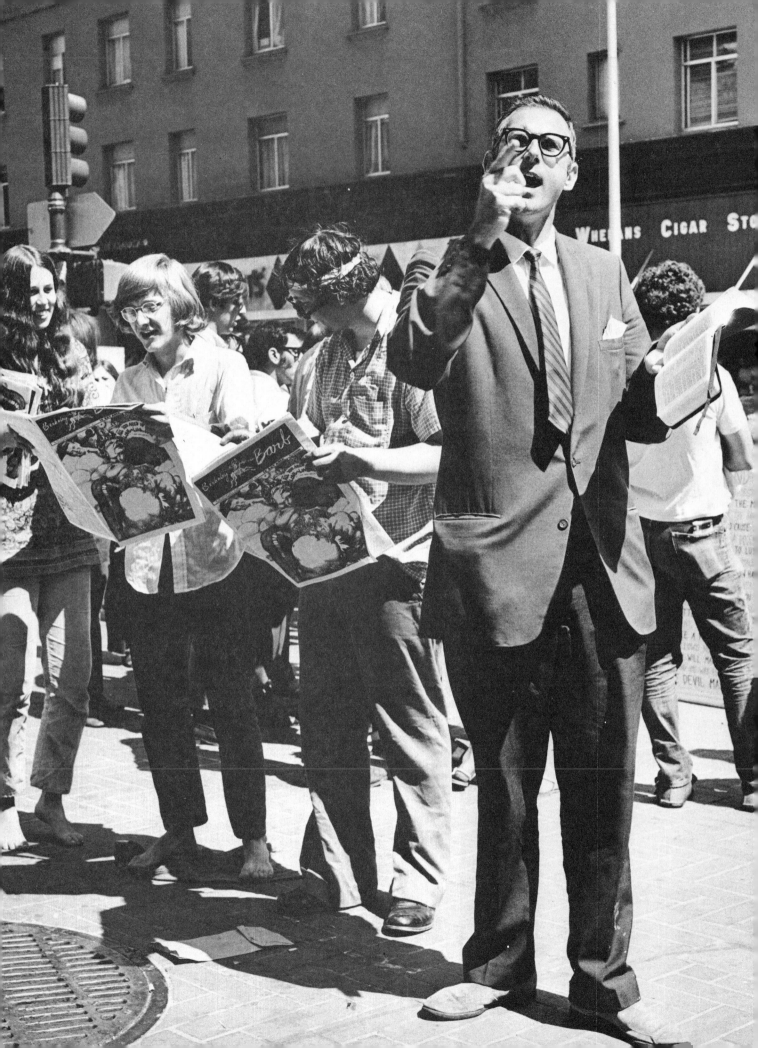

There is in man's nature a secret inclination
and motion towards love of others, which, if it be not
spent upon some one or a few, doth
naturally spread itself towards many, and maketh
men become humane and charitable, as it is
seen sometime in friars.

Francis Bacon, circa A.D. 1600

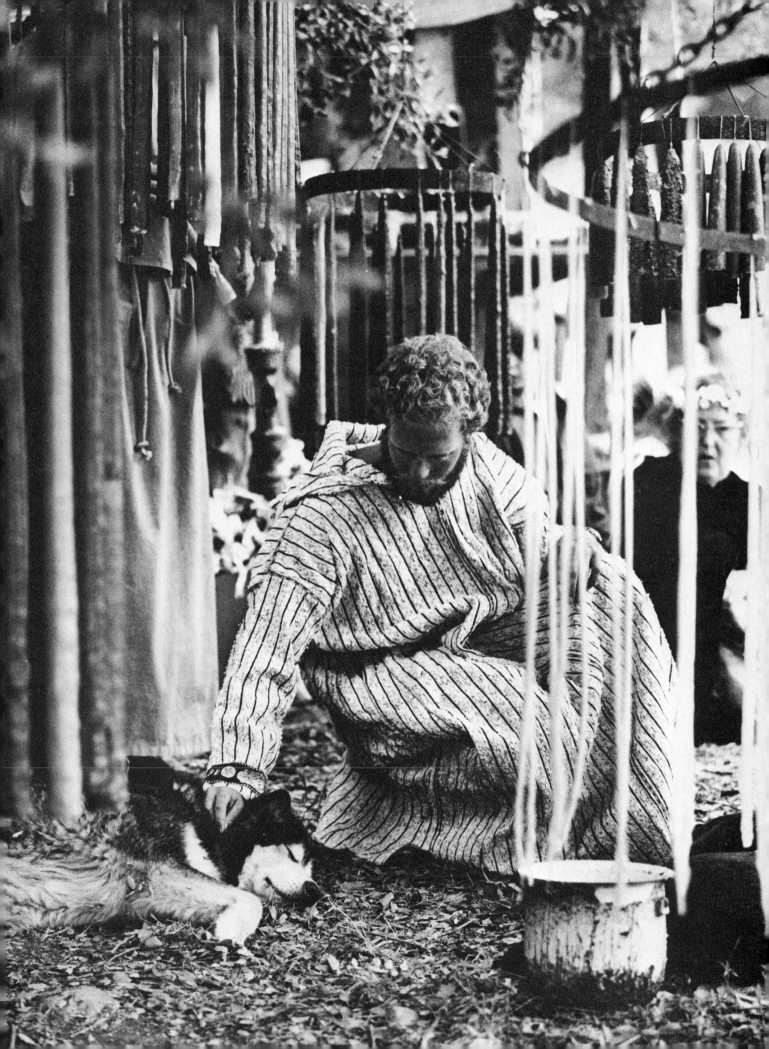

``Beauty is truth, truth beauty,''
—that is all ye know on earth, and all ye need to know.

John Keats

He who is plenteously provided for from within,
needs but little from without.

Johann Wolfgang von Goethe

You can't stop progress!

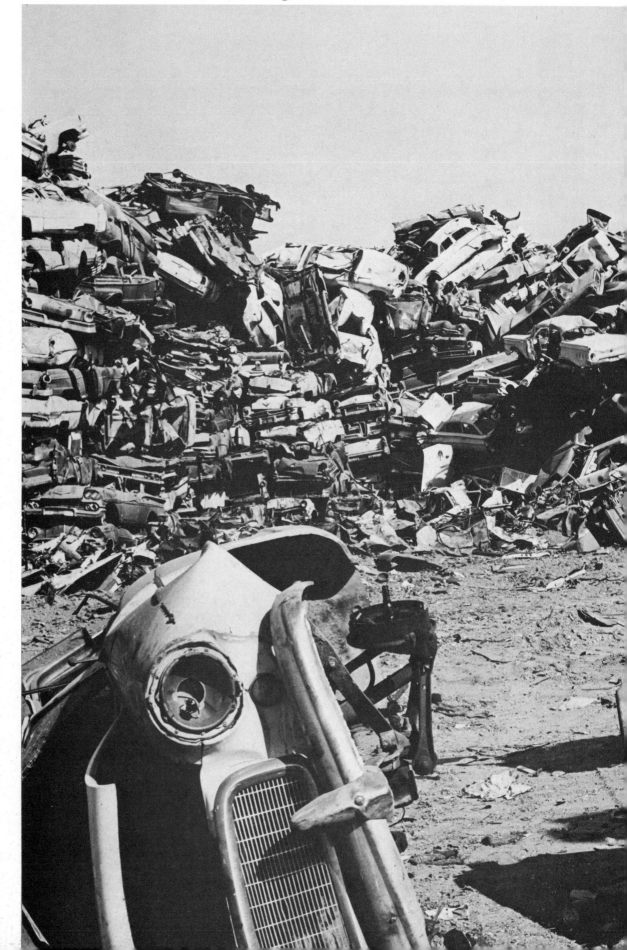

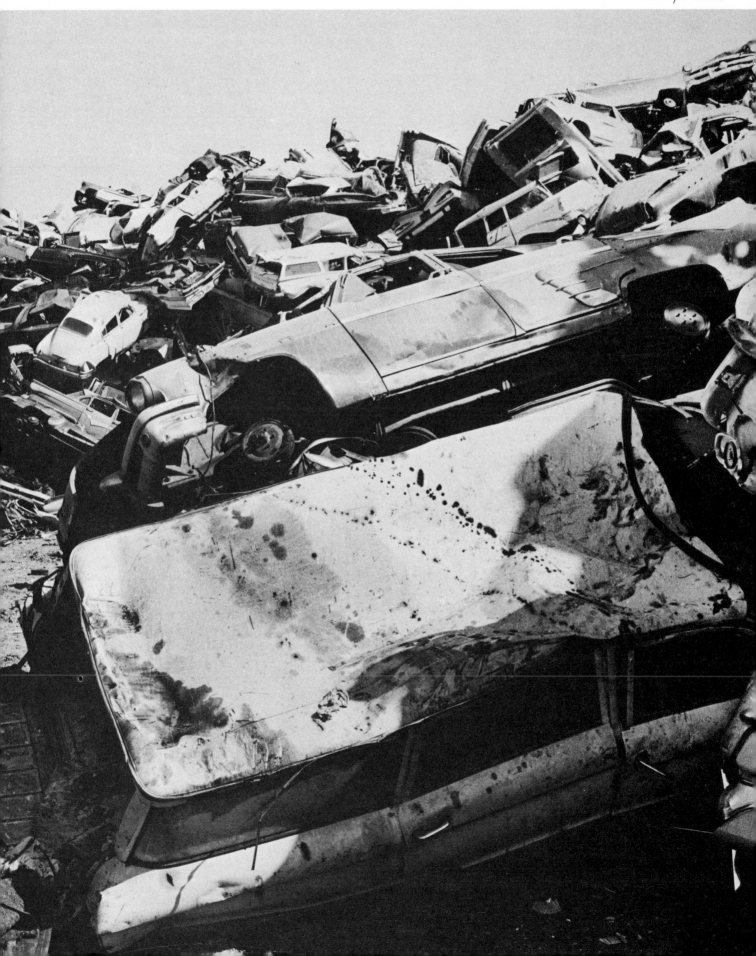

Dream Song

I

At night may I roam,
Against the winds may I roam,
At night may I roam,
When the owl is hooting may I roam.

At dawn may I roam,
Against the winds may I roam,
At dawn may I roam,
When the crow is calling may I roam.

II

How will you roam,
When there is no land?
Where will you roam,
When there is no beauty?
Why will you roam,
When there are no animals?

I. A. Grove Day, 1964
II. Jim Gorman, 1969

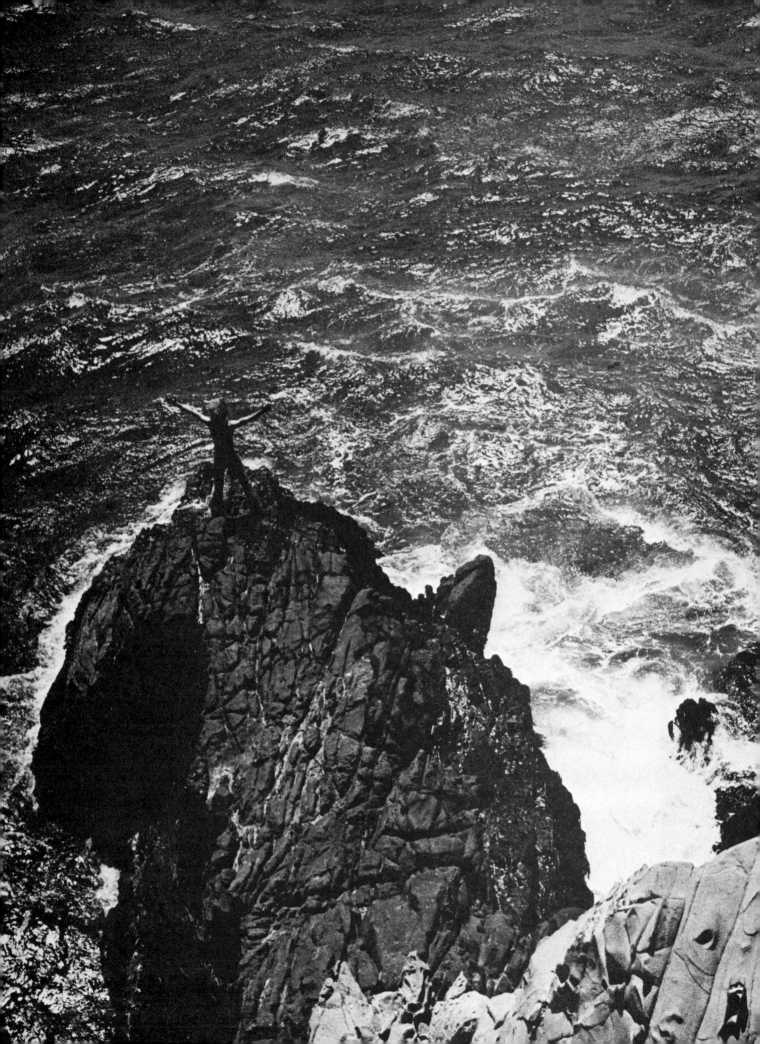

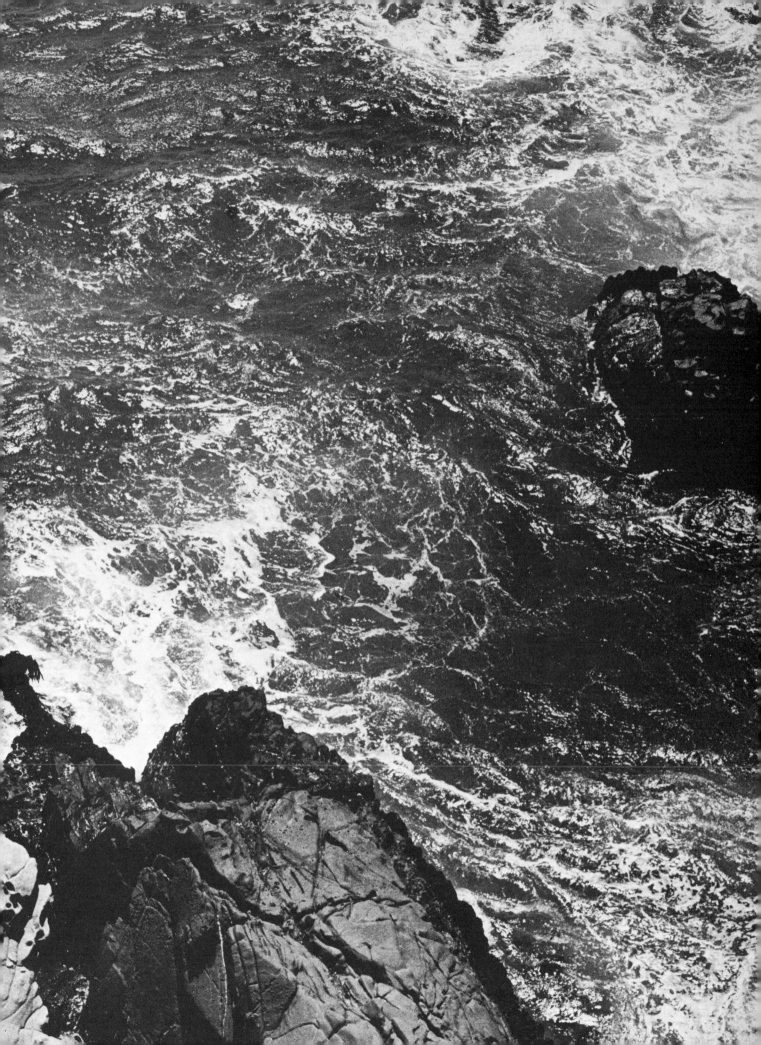

I got life, mother
I got laughs, sister
I got freedom, brother
I got good times, man

I got crazy ways, daughter
I got million dollar charm, cousin
I got headaches and toothaches and bad times, too, like you!

I got my hair
I got my head
I got my brain
I got my ears
Got my eyes
Got my nose
Got my mouth
I got my teeth!

I got my tongue
Got my chin
Got my neck
Got my tits
Got my heart
Got my soul
Got my back
I got my ass!

Got my arms
Got my hands
Got my fingers
Got my legs
Got my feet
Got my toes
Got my liver
I got my blood!
I got my guts
I got my muscles
I got Life!
Life!
Life!
Life!
Life!
Life!
Life!

HAIR, 1967

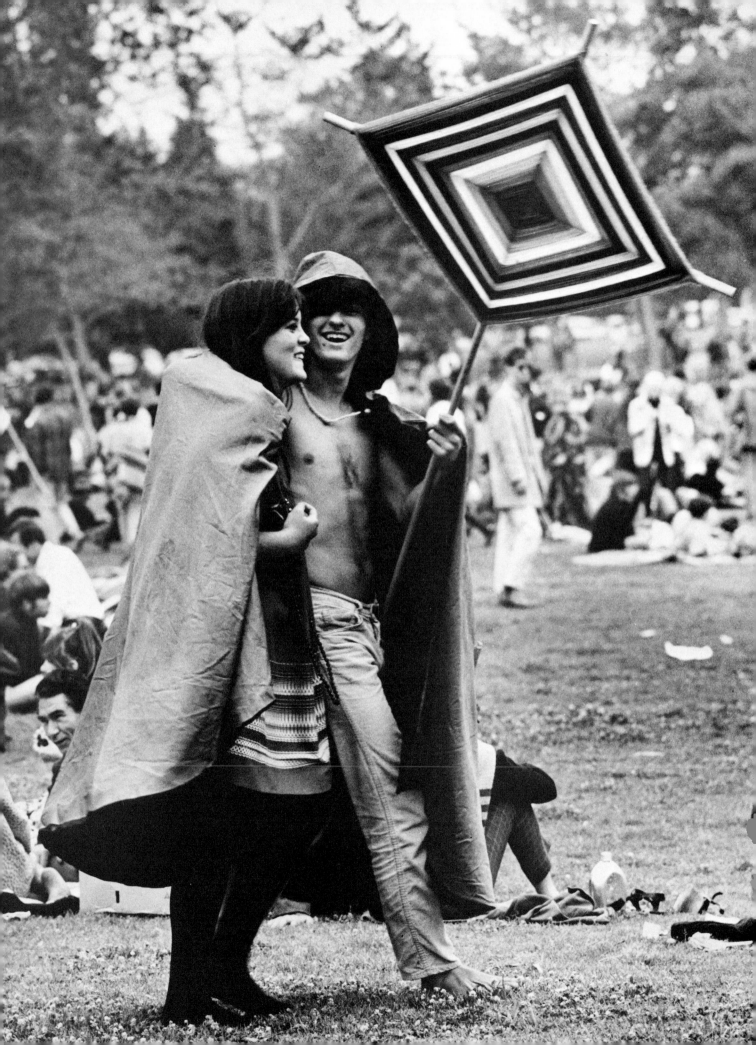

Grownups have a strange way of
putting themselves in compartments and
groups. They build up barriers...
of religion, of caste, of color, of party, of
nation, of province, of language,
of custom and of wealth and poverty.
Thus they live in prisons of
their own making.

Jawaharlal Nehru

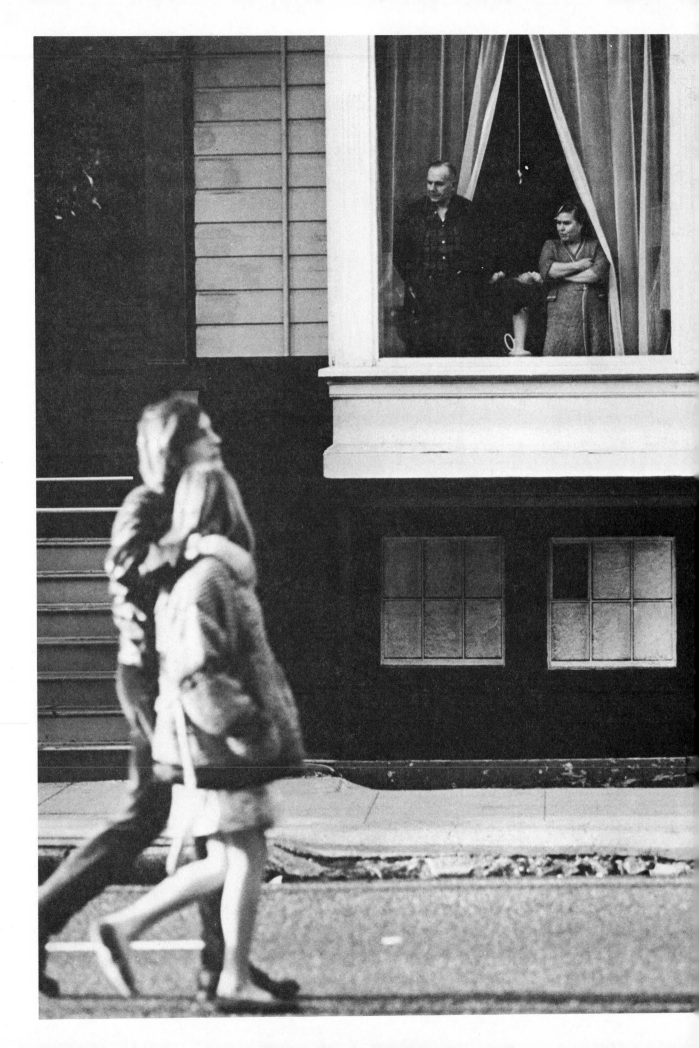

Are our schools so ineffective and our fathers and mothers so unpersuasive that there is a nation-wide subversion of youth by the glamorous appeal of the drop-out dopies? Are the standard brands of Christianity and Judaism so devoid of spiritual power that they seriously fear the competition of chemical mysticism and neo-Buddhism? Is the "American family" such a pretentious drag that it feels deeply threatened by the appearance of tribal communities where sex partnerships are fluid and children are shared in common? And is the tough-minded, hard fact-facing American male so on the edge of homosexuality that he feels physically sick and fighting mad at the resurgence of seventeenth-century cavaliers with long hair and colorful dress?

Such questions need only to be asked.

Alan Watts, 1967

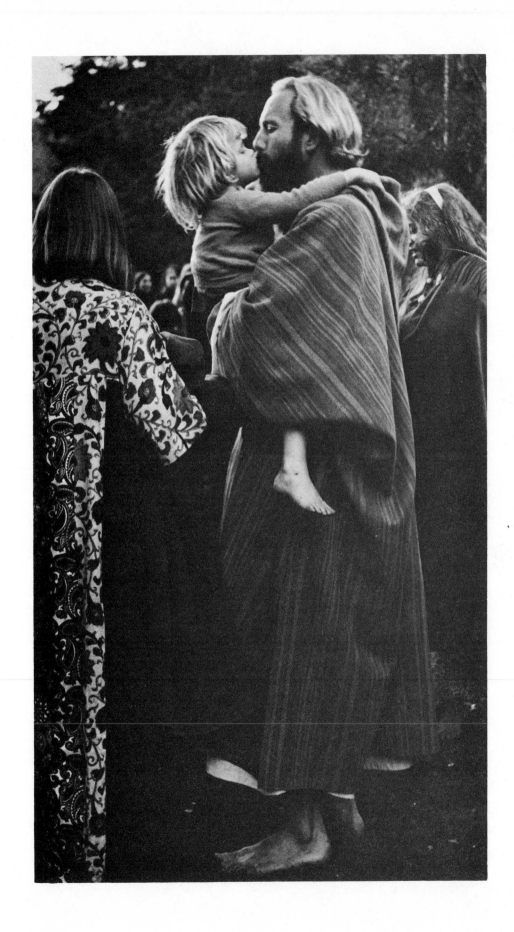

How very hard it is to be A Christian!

Robert Browning

If a man does not keep pace with his companions, perhaps it is because he hears a different drummer. Let him step to the music which he hears, however measured or far away.

Henry David Thoreau

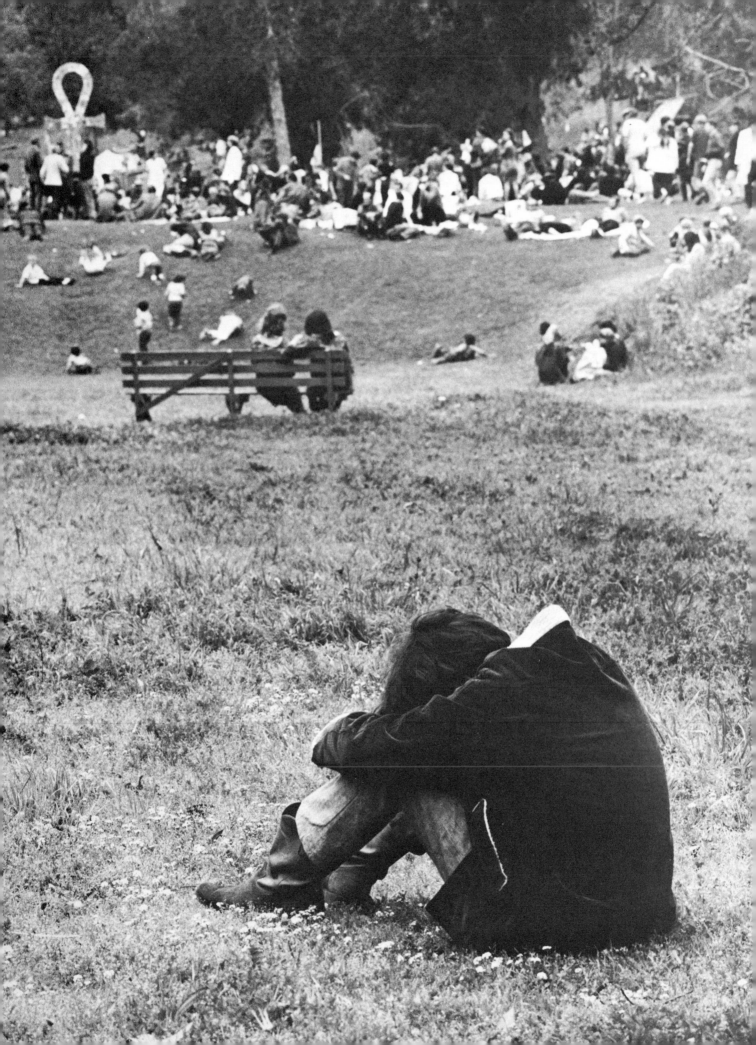

Men may believe what they cannot prove.
They may not be put to the proof of their
religious doctrines or beliefs.

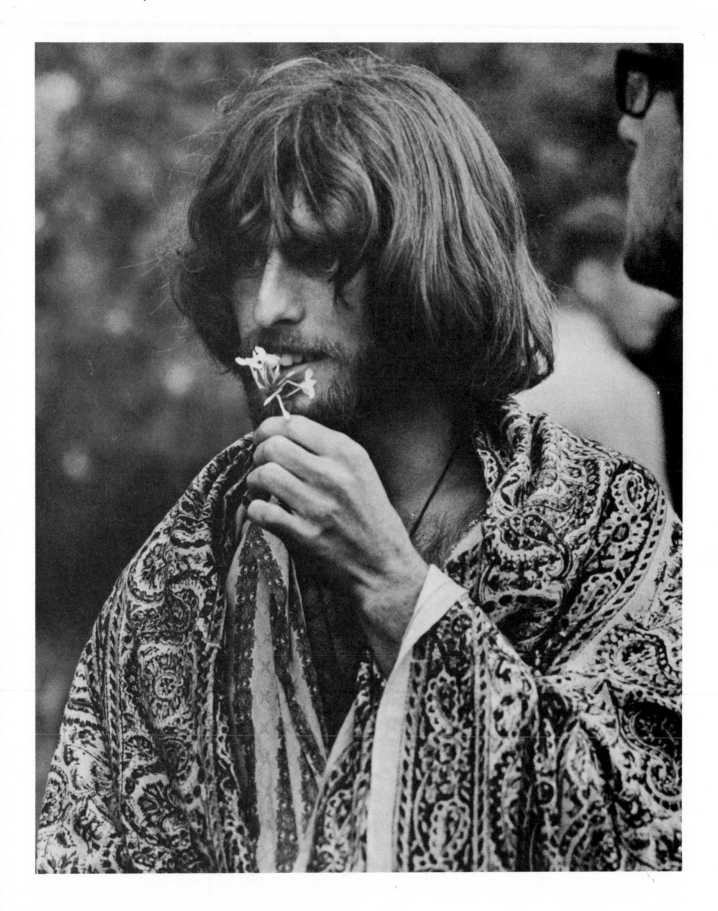

Religious experiences which are as real as life
to some may be incomprehensible to others.
William O. Douglas, Supreme Court Decision

I sent my soul
through the invisible
Some letter of that
after-life to spell
And after many days
my soul return'd
And said, "Behold,
myself am Heav'n and Hell."

Rubaiyat of Omar Khayyam

And have you traveled very far?
Far as the eye can see.
How often have you been there?
Often enough to know.
What did you see when you were there?
Nothing that doesn't show.

John Lennon/Paul McCartney

Everything has its beauty but not everyone sees it.

Confucius

And in the sweetness of friendship
let there be laughter and sharing of pleasures.
For in the dew of little things the heart
finds its morning and is refreshed.

Kahlil Gibran

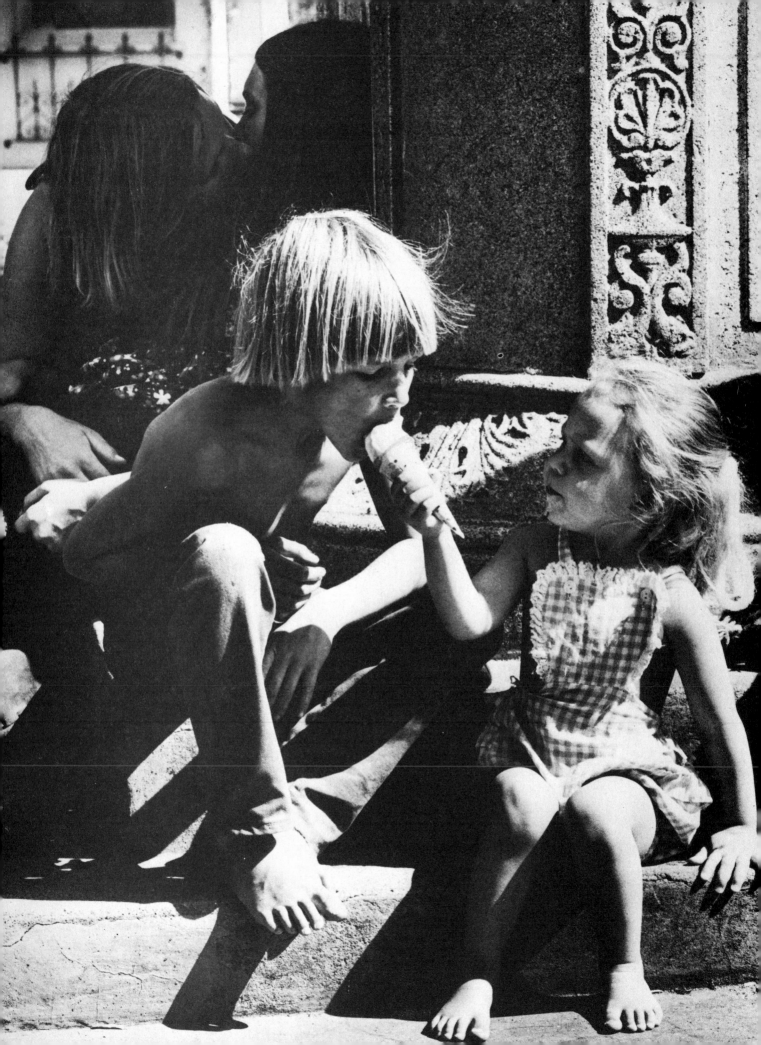

$$E=mc^2$$

Albert Einstein

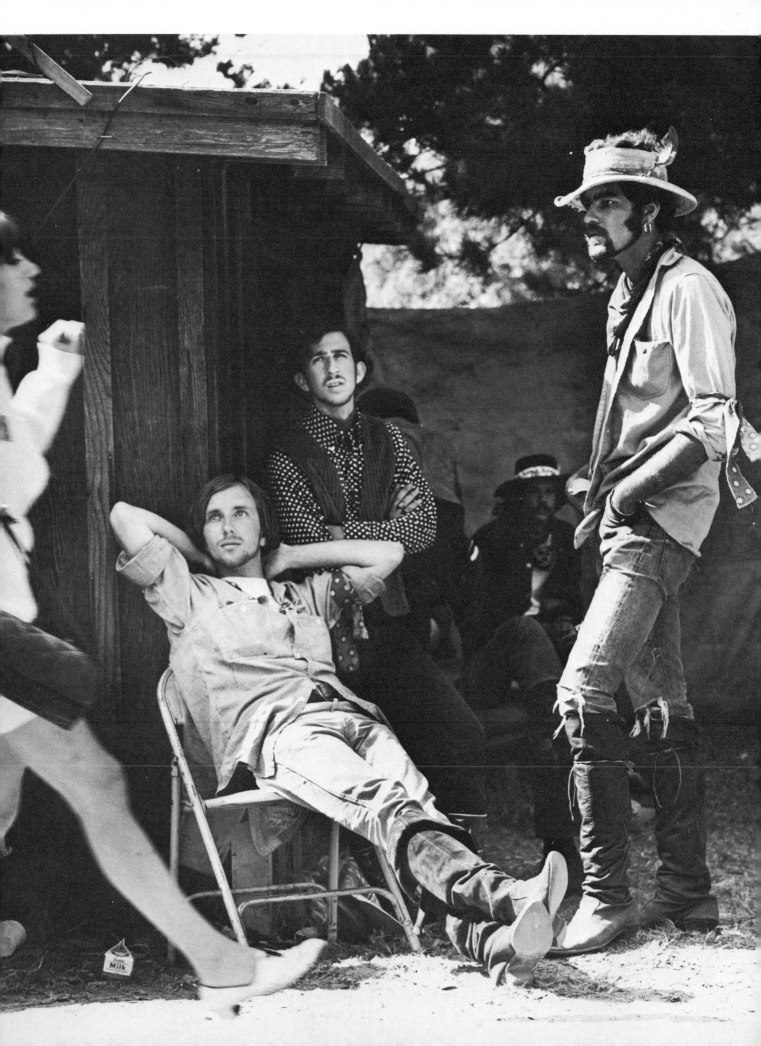

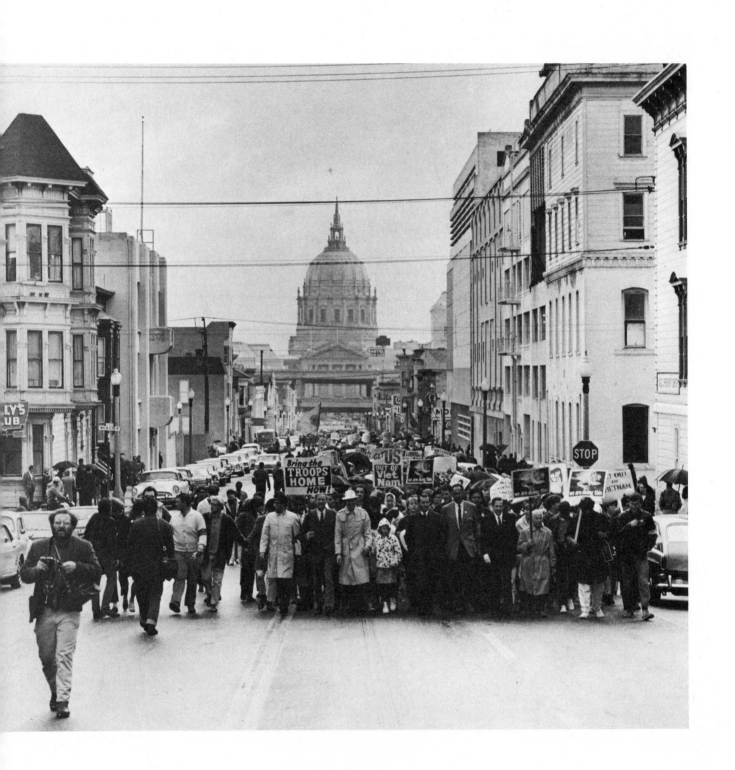

Endlessly men prate about freedom,
and shout and demonstrate and
riot and demand Congressional
legislation and civil rights. All in vain.
The fetters are inward, the bondage
is spiritual.

Robert S. DeRopp

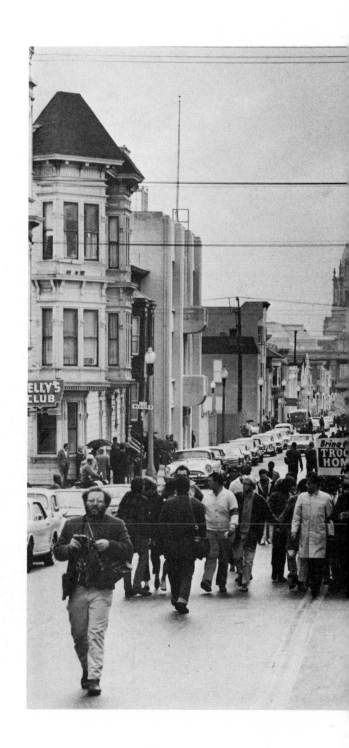

Man
is something that is to be surpassed.
What have you done to surpass
him?

Friedrich Nietzsche

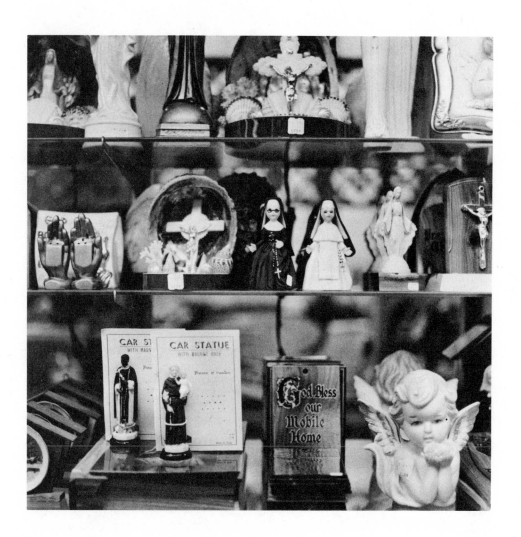

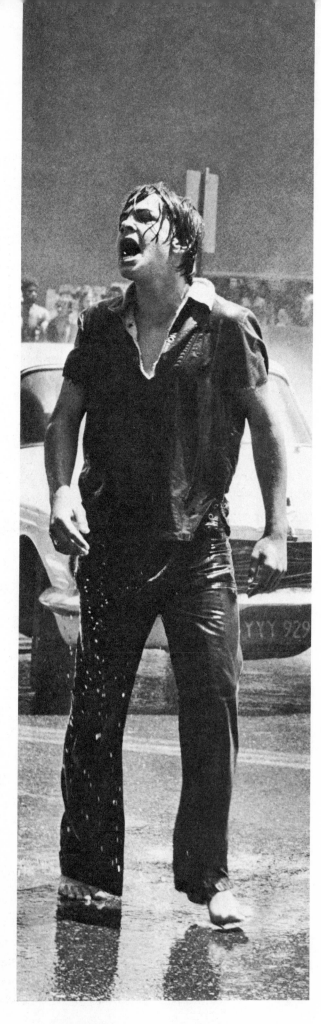

The best way of avenging thyself is not to become like the wrong-doer.

Marcus Aurelius Antoninus

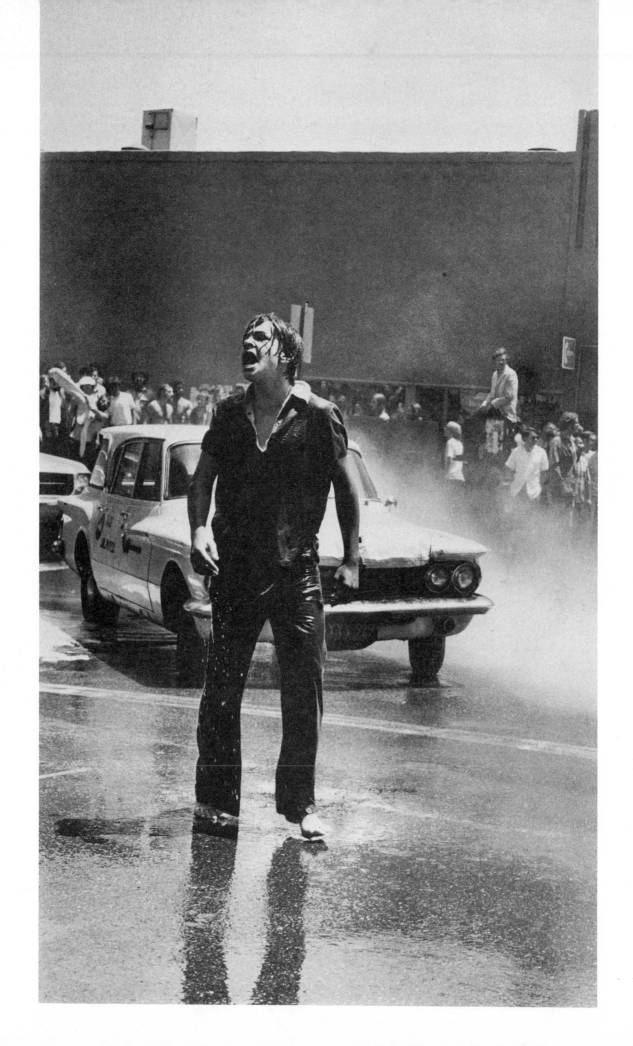

The god of victory is said to be one-handed,
but Peace gives victory to both sides.

Ralph Waldo Emerson

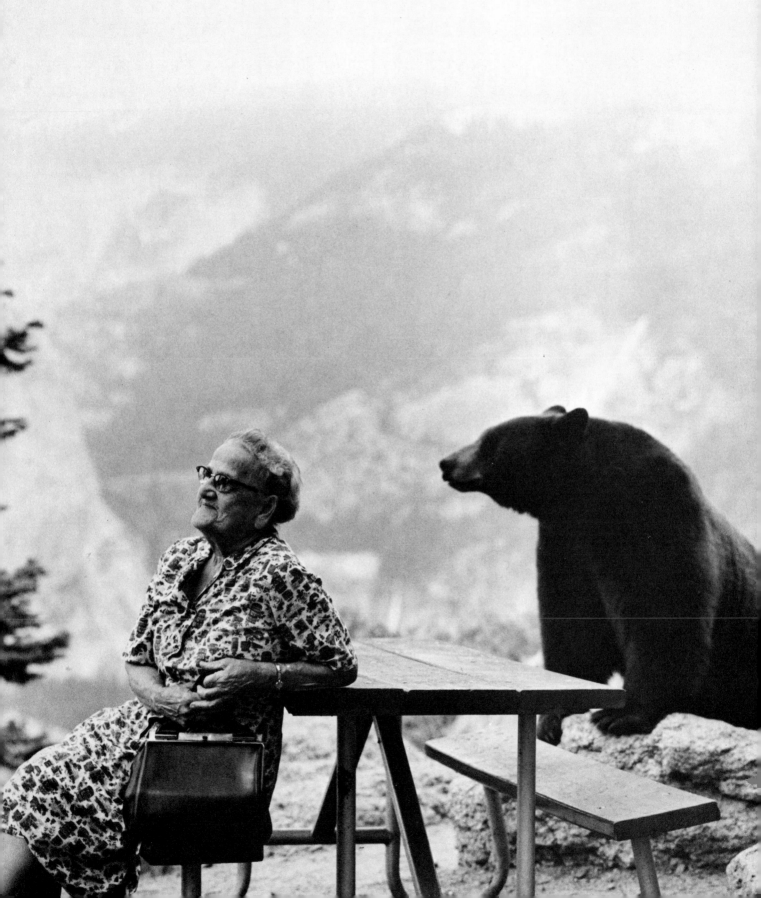

Has any man attained to inner harmony
by pondering the experience of others? Not since
the world began! He must pass through the fire.

Norman Douglas

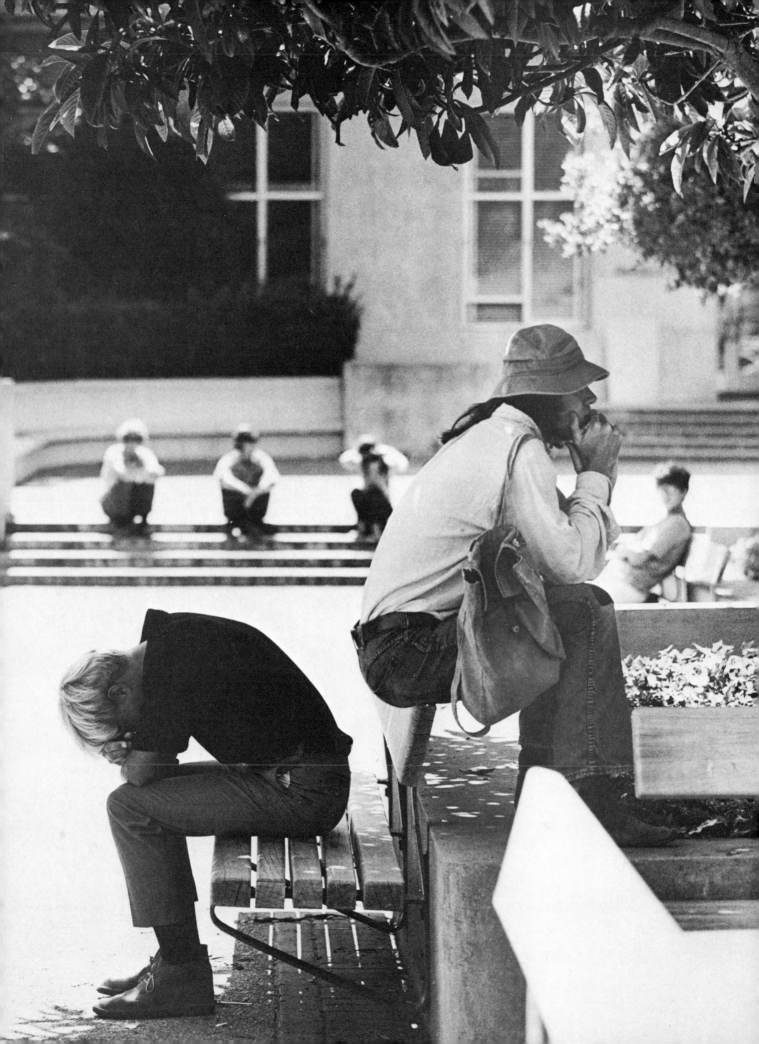

...One is a number
Divided by two...

Nilsson

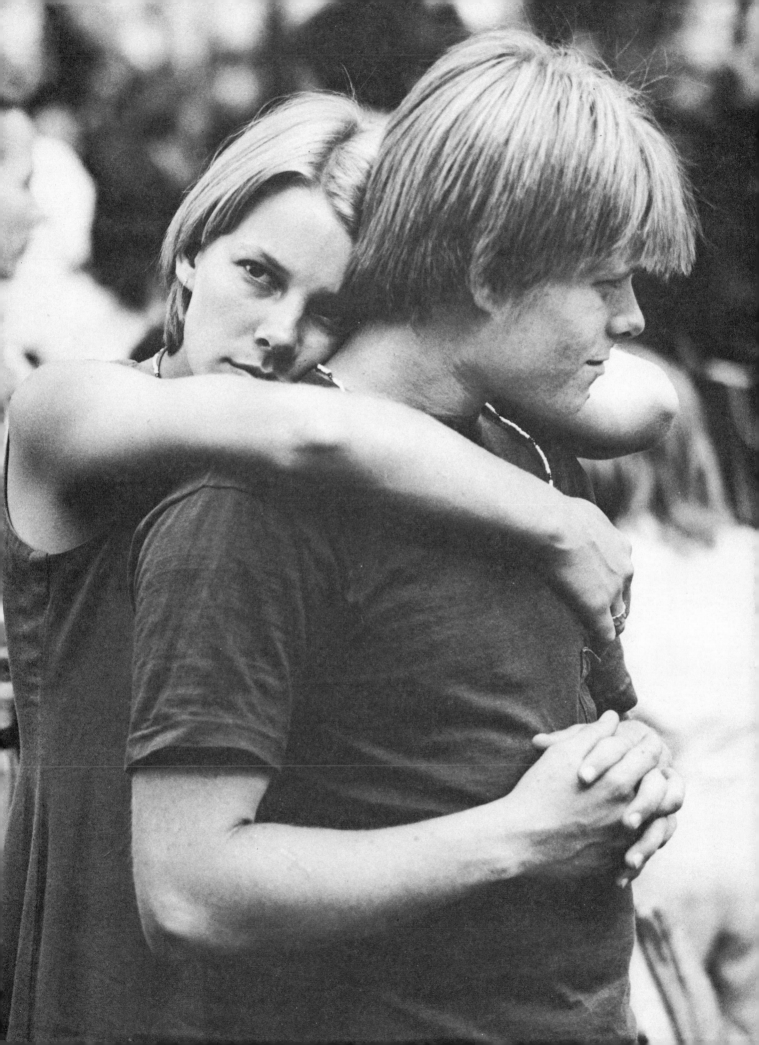

You may give them your love but not your thoughts,
For they have their own thoughts.
You may house their bodies but not their souls,
For their souls dwell in the house of tomorrow,
 which you cannot visit, not even in your dreams.
You may strive to be like them, but seek not to
 make them like you.
For life goes not backward nor tarries with yesterday.

Kahlil Gibran

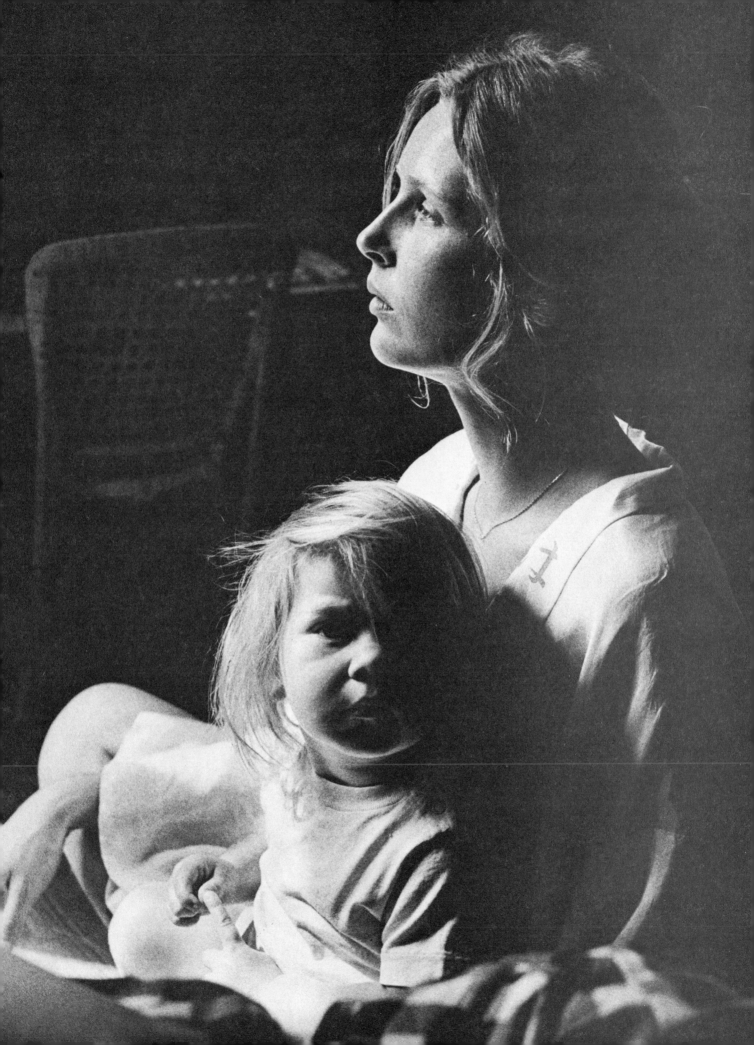

We should welcome the excesses of youth
just as we welcome the exuberance of spring,
looking forward with delight to the time when people
with such an imaginative program for life
become mellow and mature — not only gentle
as doves, but wise as serpents.

Alan Watts, 1967

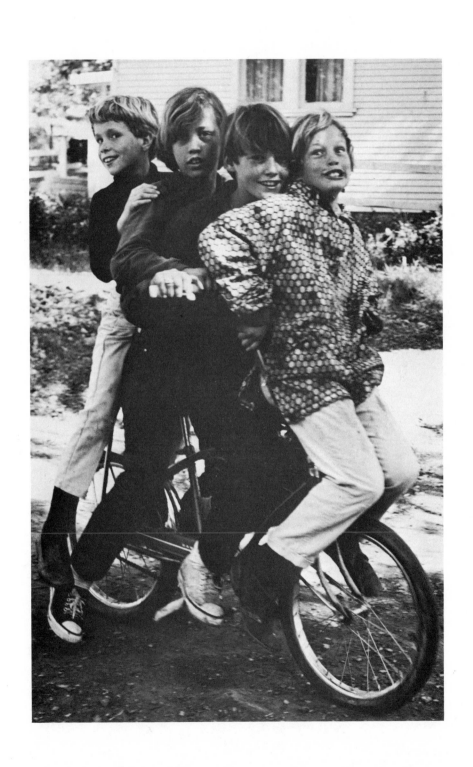

If we can combine our knowledge of science with the wisdom of wildness, if we can nurture civilization through roots in the primitive, man's potentialities appear to be unbounded. Through his evolving awareness, and his awareness of that awareness, he can merge with the miraculous — to which we can attach what better name than "God"? And in this merging, as long sensed by intuition but still only vaguely perceived by rationality, experience may travel without need for accompanying life.

Charles A. Lindbergh, 1969

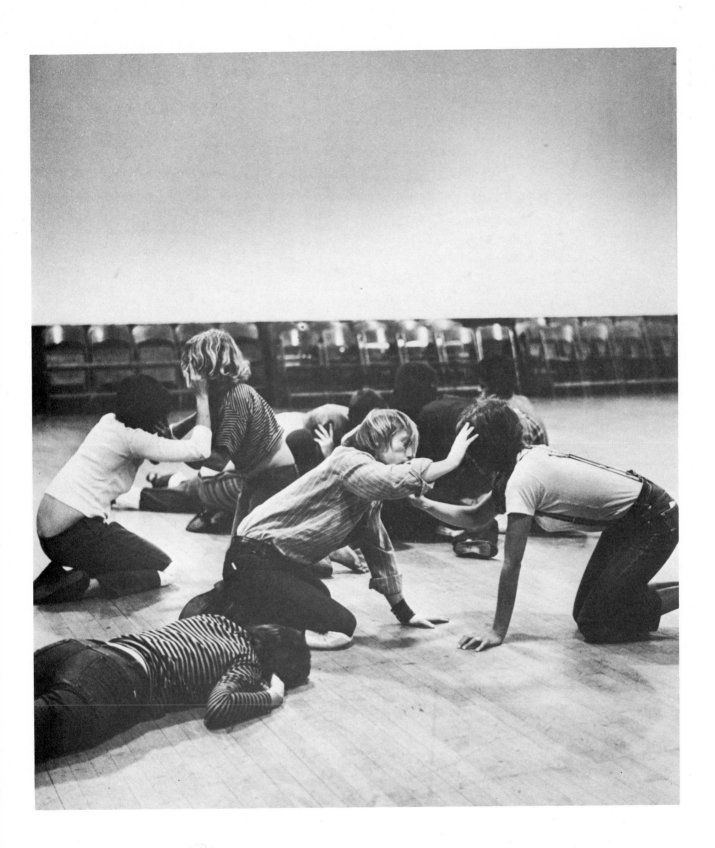

The aim of the game is true awakening, full development of the powers latent in man. The game can be played only by people whose observations of themselves and others have led them to a certain conclusion, namely, that man's ordinary state of consciousness, his so-called waking state, is not the highest level of consciousness of which he is capable. In fact, this state is so far from real awakening that it could appropriately be called a form of somnambulism, a condition of "waking sleep."

Robert S. DeRopp

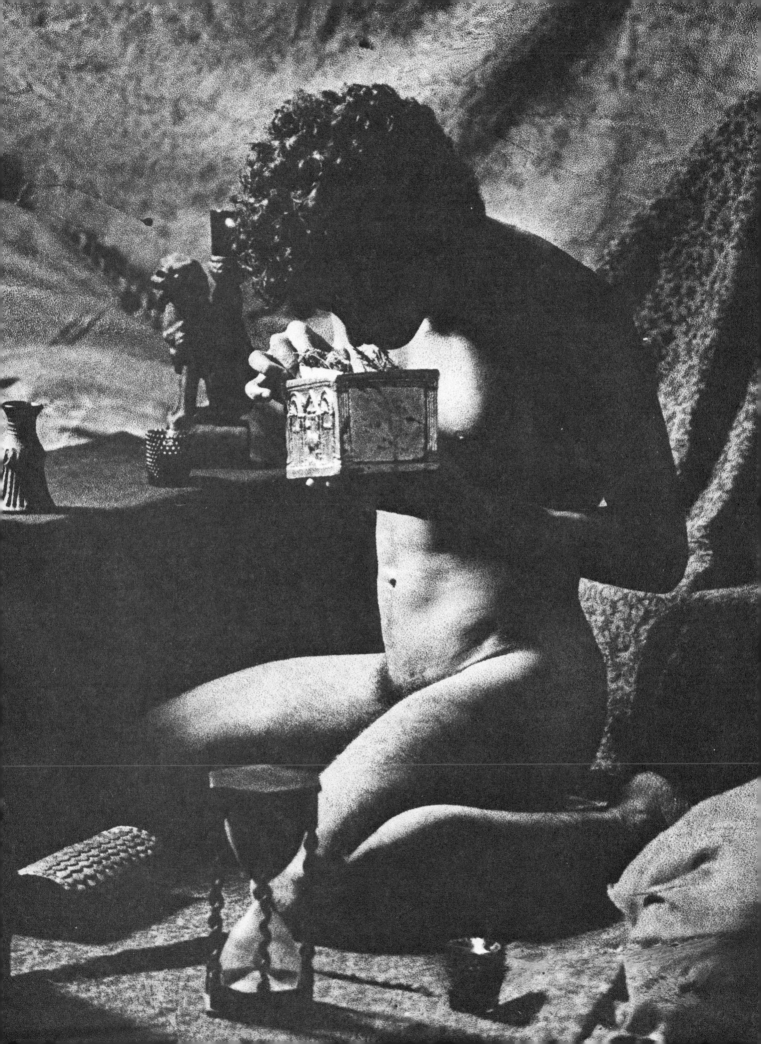

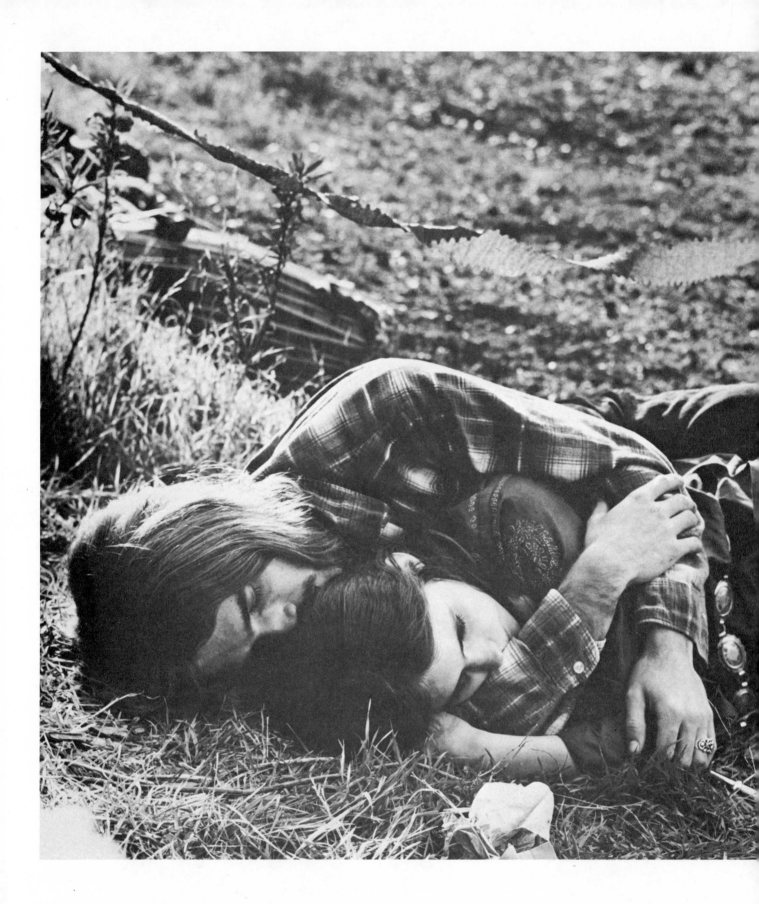

...All of us look at each other knowingly, for the feeling that we knew each other in that most distant past conceals something else—tacit, awesome, almost unmentionable— the realization that at the deep center of a time perpendicular to ordinary time we are, and always have been, one. We acknowledge the marvelously hidden plot, the master illusion, whereby we appear to be different.

Alan Watts, 1962

Nothing can happen to you which is not a manifestation of your own state of consciousness.

Joel Goldsmith

Be still,

and know that I am God.... Psalms 46:10

Quiet minds cannot be perplexed or frightened, but go on in fortune or misfortune at their own private pace, like a clock in a thunderstorm.

Robert Louis Stevenson

Experience

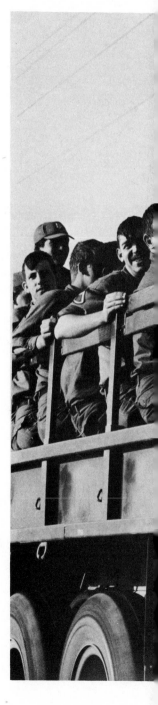

is not what happens to a man;

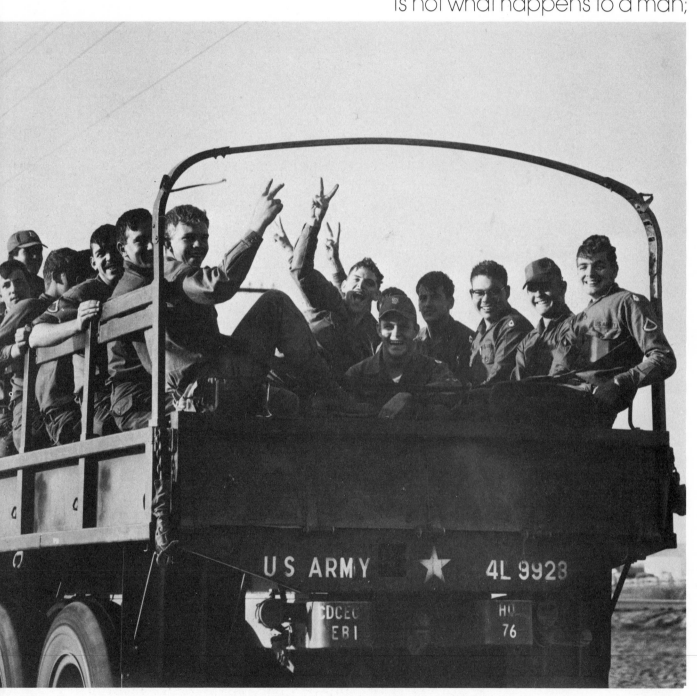

US ARMY ★ 4L 9923

it is what a man does with what happens to him.

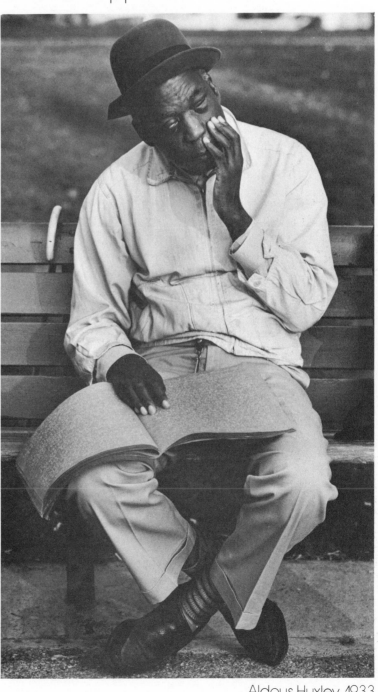

Aldous Huxley, 1933

...our normal waking consciousness, rational consciousness as we call it, is but one special type of consciousness, whilst all about it, parted from it by the filmiest of screens, there lie potential forms of consciousness entirely different. We may go through life without suspecting their existence, but apply the requisite stimulus, and at a touch they are there in all their completeness....No account of the universe in its totality can be final which leaves these other forms of consciousness quite disregarded.

William James, 1902

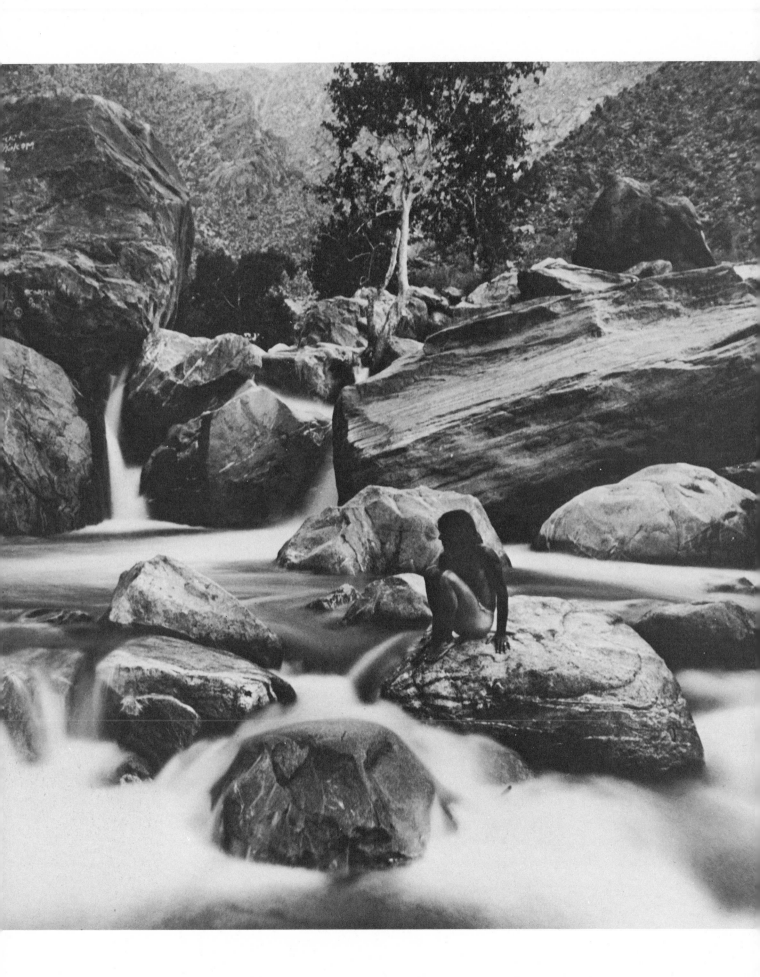

I knew that all the hundred thousand
pieces of life's game were in my pocket.
A glimpse of its meaning had stirred
my reason and I was determined to begin the
game afresh. I would sample its tortures
once more and shudder again at its
senselessness. I would traverse not once more, but
often, the hell of my inner being. One day
I would be a better hand at the game.
One day I would learn how to laugh.

Herman Hesse

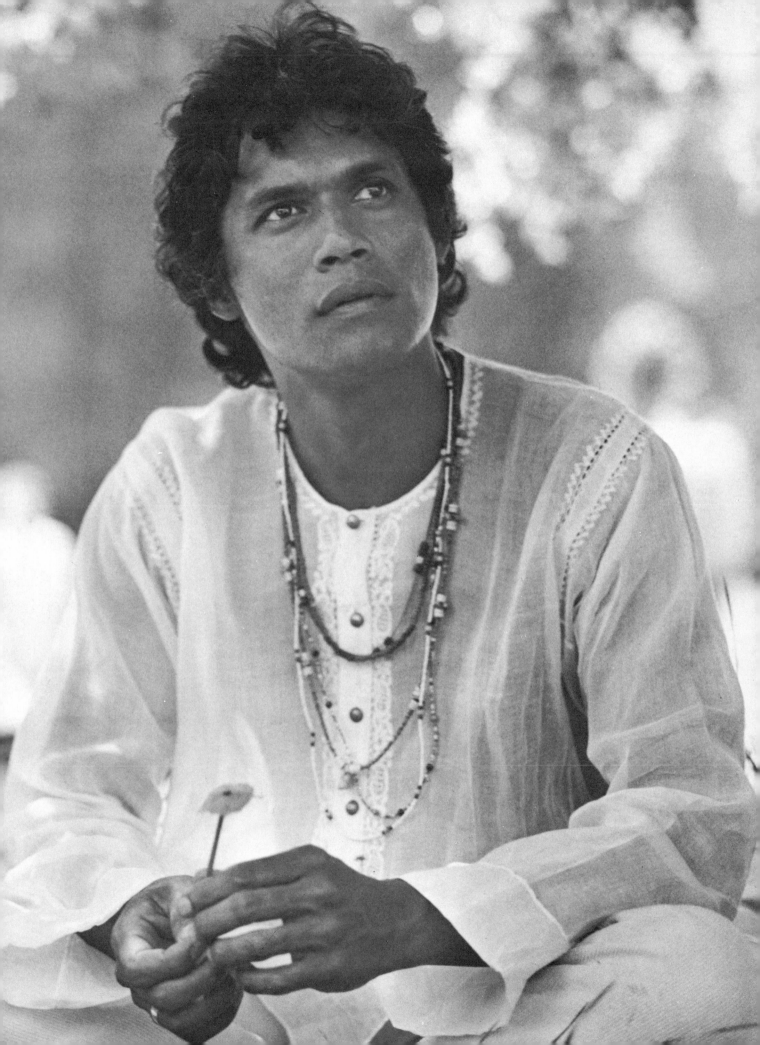

If you cannot pay your debts without selling the house, sell it. If you have no umbrella in the rain, get wet. Does it matter? All things, your house and your umbrella included, have no validity outside your mind, and even your body will go in a few years, or perhaps tomorrow. All problems, even of the twin illusions of life and death, are alike good fun, if so regarded. Was any man ever the happier for being unhappy about death, and did he live any longer? Is suffering made the less by tears about it? Or another's pain removed by your abundant gloom?

Do what seems wise to be done, forget it and walk on. Even if you come to a precipice, why walk round it or back from it? Why not go over it? It is probably the shortest way there!

Christmas Humphreys

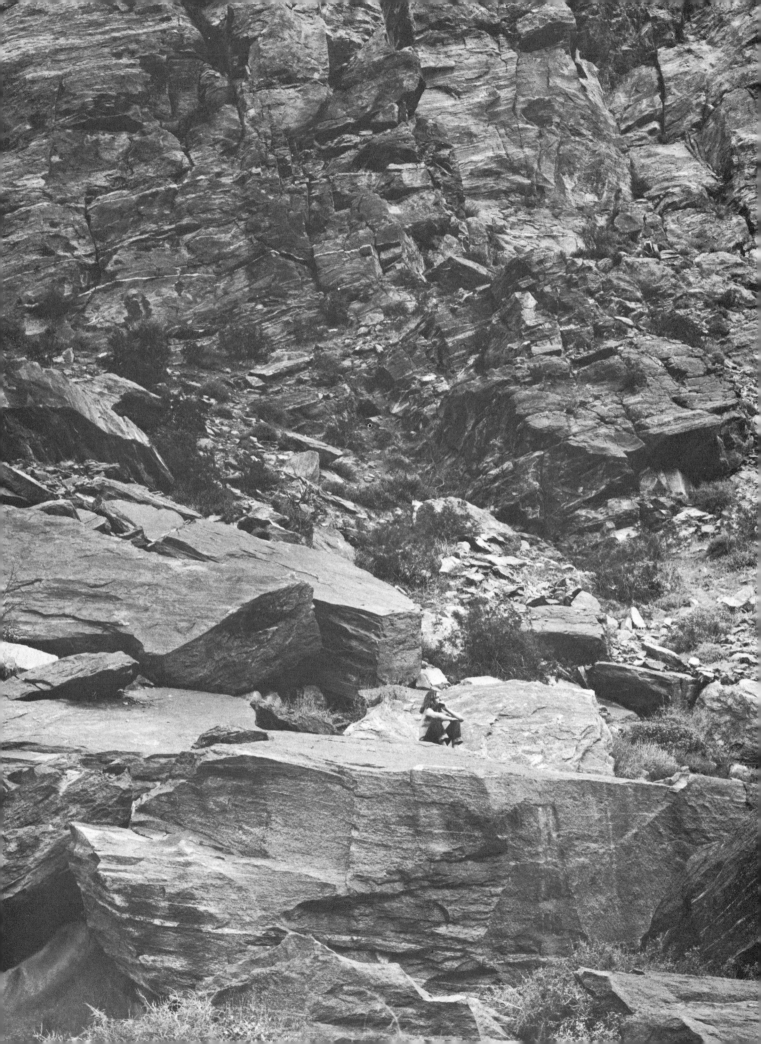

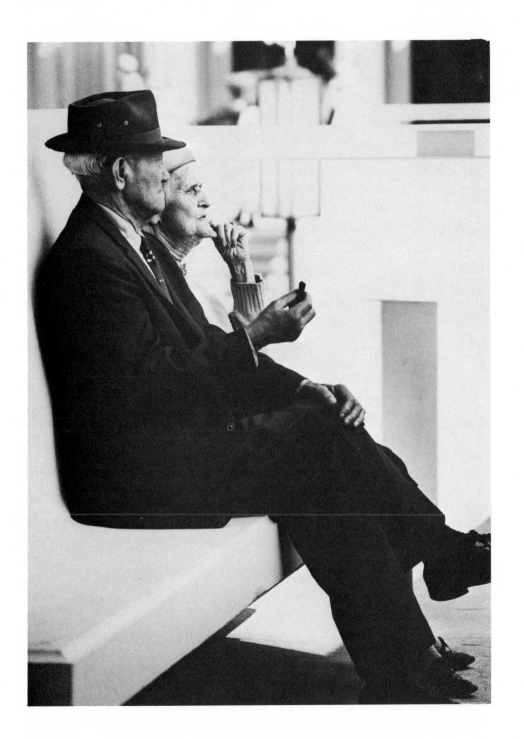

...those

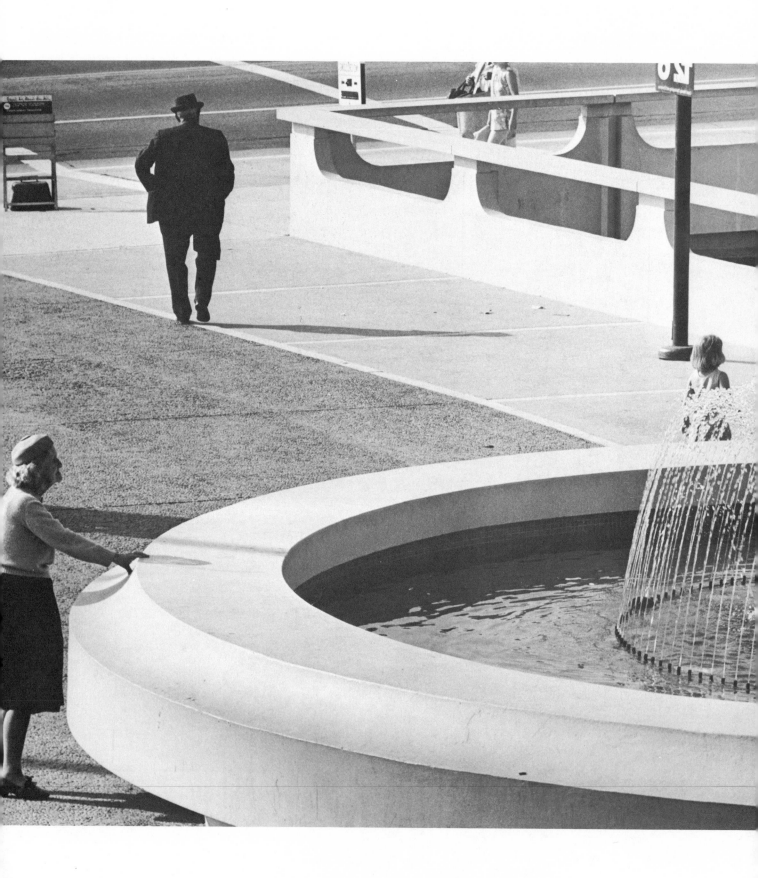

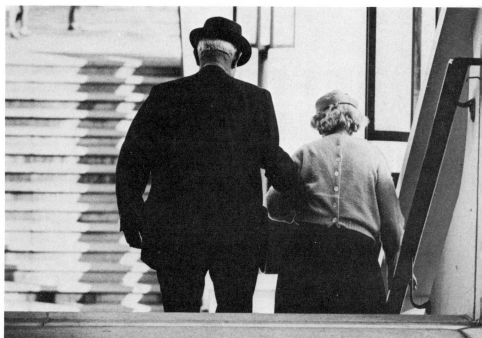

who find their encouragement and
inspiration in precisely the present condition of
things, and cherish it with the fondness and
enthusiasm of lovers...

Henry David Thoreau

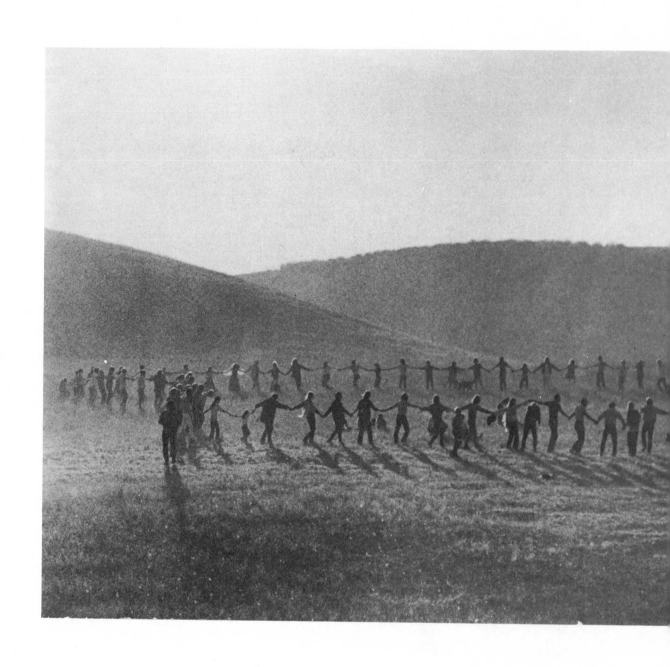

What Christ is saying always, what he never swerves
from saying, what he says a thousand times and in a thousand
different ways, but always with a central unity of belief, is this:

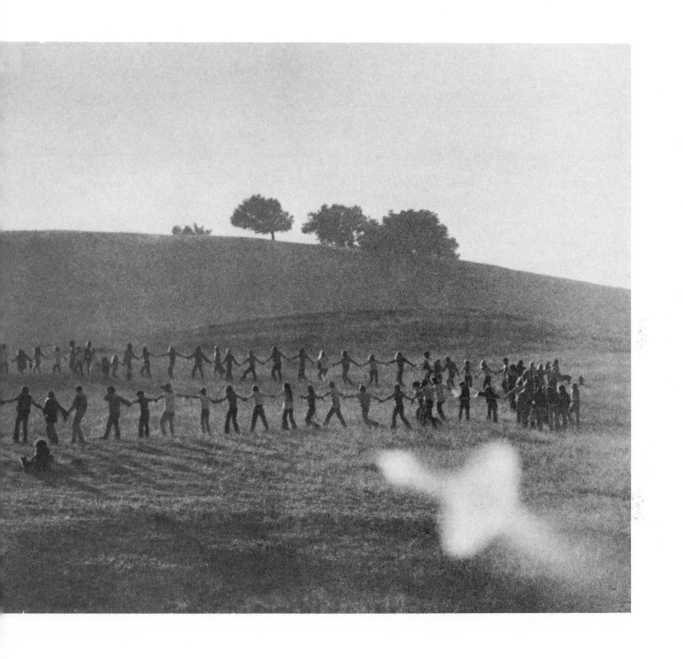

"I am my father's son, and you are my brothers." And the unity
that binds us all together, that makes this earth a family, and all
men brothers and so the sons of God, is love.
 Thomas Wolfe

Then spake Arjuna, unto the Blessed Lord, Krishna, saying:

"Thou hast removed my illusion and ignorance, by Thy words of Wisdom, regarding the Supreme Mystery of the Spirit, which Thou hast spoken unto me out of Thy great love and compassion. From Thee I have learned the full truth regarding the creation and destruction of all things; and also concerning Thy greatness and all-embracing immanence. Thou art indeed the Lord of All, even as Thou describeth Thyself. But, one final token of Thy love for me, I beg of Thee, O Lord and Master. I would, if such be possible for me, that Thou showeth unto me Thine own Countenance and Form — the Imperishable Spirit."

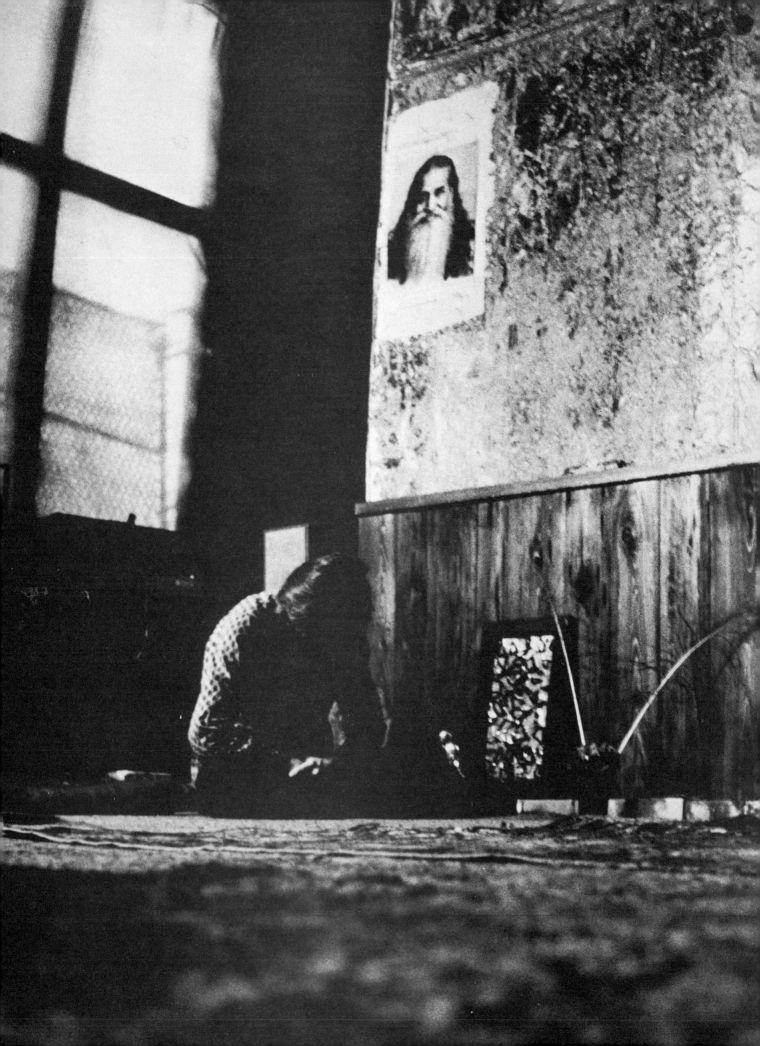

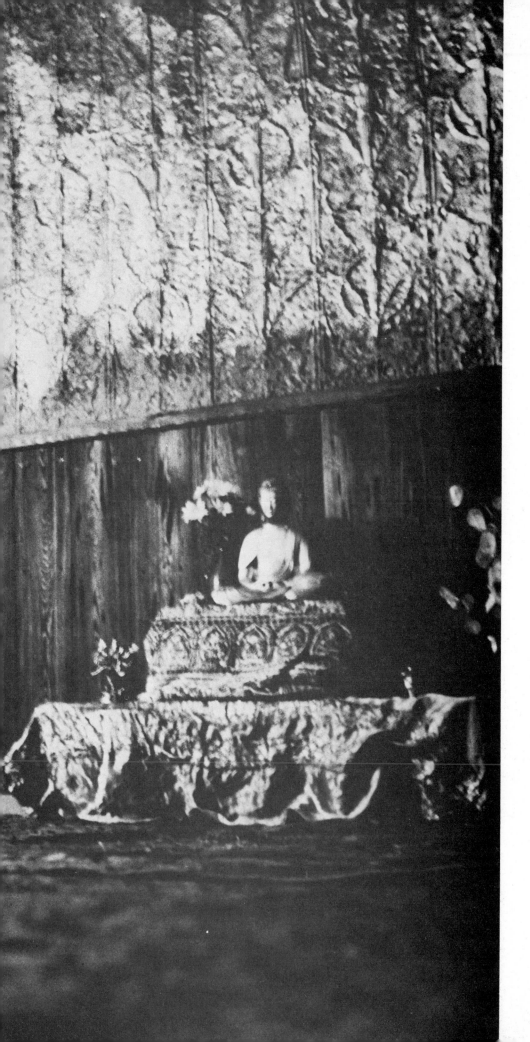

Turn off your mind,
Relax and float downstream,
It is not dying,
It is not dying.

Lay down all thought,
Surrender to the void,
It is shining,
It is shining.

That you may see
The meaning of within,
It is speaking,
It is speaking.

John Lennon/Paul McCartney

And Krishna answered: "Since thou asketh me for this, O Arjuna, even shalt it be granted thee. Behold, then, O Prince, my millions of forms divine, of all shapes and forms, species, colors and kinds. Behold thou first the numberless heavenly hosts and celestial beings — angels; arch-angels; planetary gods; rulers of universes; and many other wonderful and mighty beings scarce dreamt of in thy wildest speculations and fancies, O Arjuna.

"Then behold as a Unity, standing within My body, the whole Universe, animate and inanimate, and all things else that thy mind impelleth thee to see. . . . But not with thine natural human eye see these things, O Arjuna, for they are finite and imperfect. But now I endow thee with the Eye of the Spirit with which thou mayest see the glorious sight awaiting thee."

The Bhagavad Gita

. . . (the star-child) waited, marshaling
his thoughts and brooding over his still untested
powers. For though he was master of the world,
he was not quite sure what to do next.
But he would think of something.

Arthur C. Clarke

I am he
As you are he
As you are me
And we are
all

...together.

John Lennon/Paul McCartney

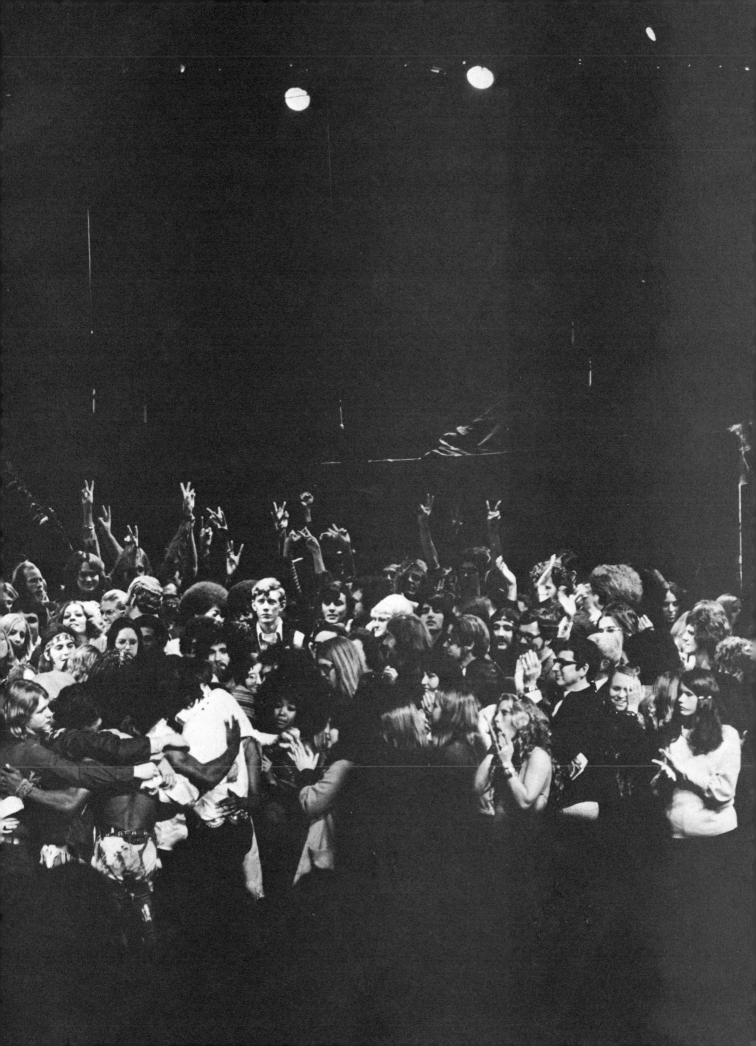

Q. There is a goose in a bottle. How to get the goose out of the bottle without hurting the goose or breaking the bottle?

A. There — it's out!

Zen koan

Today
is the first day
of the rest of your life.

Anonymous graffiti, 1967

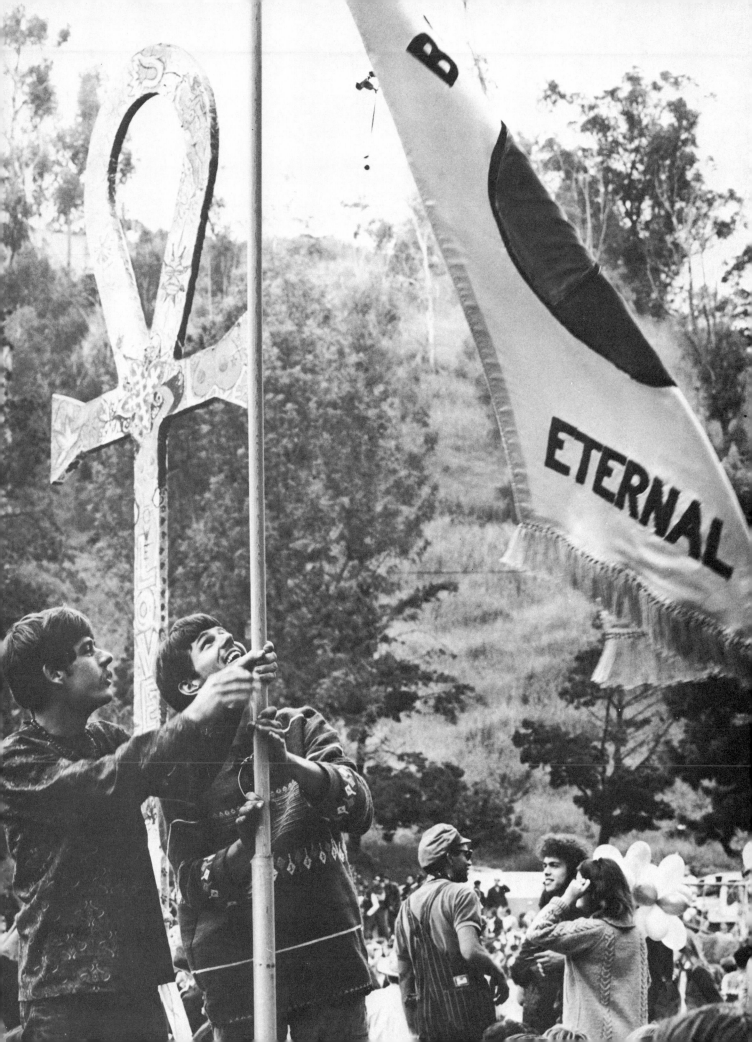

Believe nothing, O monks, merely because you have been told it...or because it is traditional, or because you yourselves have imagined it. Do not believe what your teacher tells you merely out of respect for the teacher. But whatsoever, after due examination and analysis, you find to be conducive to the good, the benefit, the welfare of all beings — that doctrine believe and cling to, and take it as your guide.

Gautama Buddha